Children's Portrait
PHOTOGRAPHY HANDBOOK

Bill Hurter

AMHERST MEDIA, INC. ■ BUFFALO, NY

ABOUT THE AUTHOR

Bill Hurter started out in photography in 1972 in Washington, DC, where he was a news photographer. He even covered the political scene—including the Watergate hearings. After graduating with a BA in literature from American University in 1972, he completed training at the Brooks Institute of Photography in 1975. Going on to work at *Petersen's PhotoGraphic* magazine, he held practically every job except art director. He has been the owner of his own creative agency, shot stock, and worked assignments (including a year or so with the L.A. Dodgers). He has been directly involved in photography for the last thirty years and has seen the revolution in technology. In 1988, Bill was awarded an honorary Masters of Science degree from the Brooks Institute. He has written more than a dozen instructional books for professional photographers and is currently the editor of *Rangefinder* magazine.

Front cover photograph by Stacy Bratton.
Back cover photographs by Jeff Hawkins Photography (top) and Kersti Malvre (bottom).

Published by:
Amherst Media, Inc.
P.O. Box 586
Buffalo, N.Y. 14226
Fax: 716-874-4508
www.AmherstMedia.com

Publisher: Craig Alesse
Senior Editor/Production Manager: Michelle Perkins
Assistant Editor: Barbara A. Lynch-Johnt

ISBN-13: 978-1-58428-208-2
Library of Congress Control Number: 2006937281
Printed in Korea.
10 9 8 7 6 5 4 3 2 1

TABLE OF CONTENTS

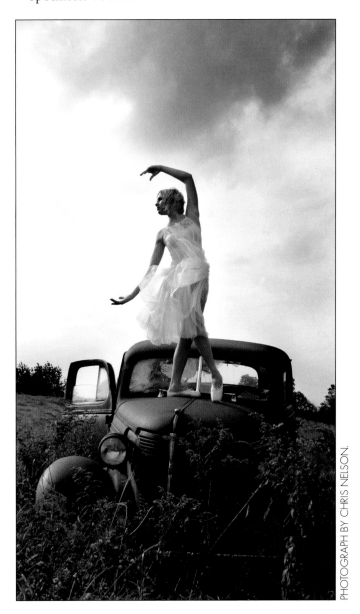

PHOTOGRAPH BY CHRIS NELSON.

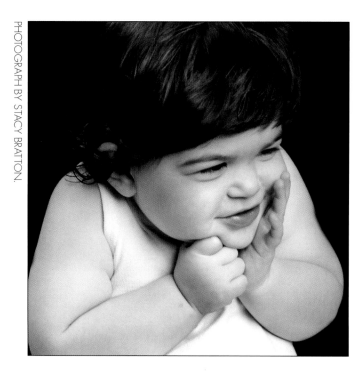

PHOTOGRAPH BY STACY BRATTON.

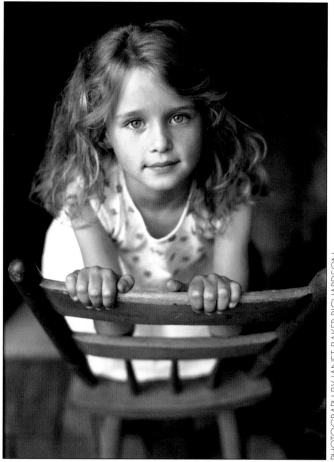

PHOTOGRAPH BY JANET BAKER RICHARDSON.

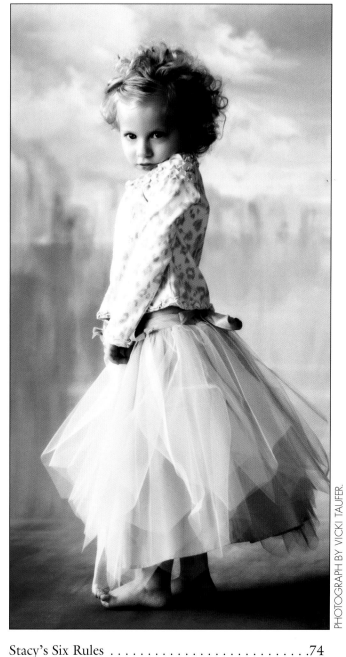

PHOTOGRAPH BY VICKI TAUFER.

W orking with babies, small children and teenagers can be a frustrating experience for any professional photographer. Kids of all ages are unpredictable. Things can be going along well during a session when, for no apparent reason, the mood changes

and you are suddenly dealing with an uncooperative subject or, in the worst case scenario, a screaming out-of-control subject.

It doesn't seem to matter what personality type you are as a photographer, kids are either generally responsive to you, or they aren't—and predicting which way it will go can be difficult. I know photographers who are gruff and generally grumpy most of the time. One reasons, "If he's this bad with adults, how can children tolerate him?" But, at least in the case of one photographer, children seem to love this otherwise grumpy Gus and are completely at ease in front of his camera.

THE CHALLENGES

Even if you do everything perfectly—producing beautiful posing and lighting, animated expressions, a wide selection of different images to choose from—the parents might say something like, "Wow, that just doesn't look like our little little boy." That's because parents form idealized mental images of their kids. When they see them in

Marcus Bell incorporates a lot of the techniques he uses in his award-winning wedding photography to photograph children. For example, he works close up with a wide-angle lens for unusual perspective, then uses selective focus to blur all but the facial elements of the portrait. His ability to get unique expressions is amazing.

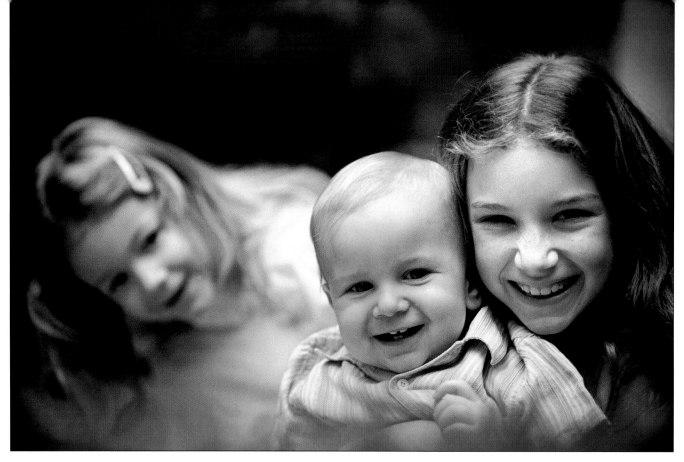

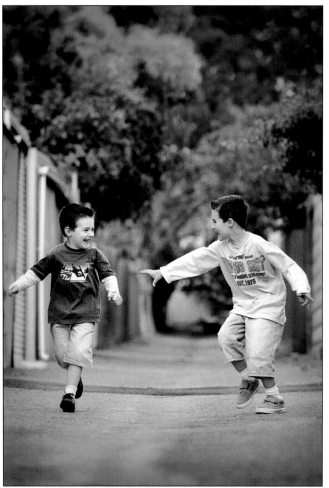

ABOVE—Photographing kids of all ages is a very special skill. Photographers like Suzette Nesire have a great knack for working with and capturing children's innermost worlds of fun. Here she photographs two sisters with their new baby brother, a newcomer with whom they are especially delighted.

LEFT—Suzette Nesire is like a child herself, capable of dissolving into the event. Here, two pals are having an animated conversation while running as fast as they can, something only children could achieve. Suzette, with the reflexes of a top sports photographer, captured them at the apex of their reverie.

pictures, then, they sometimes don't emotionally relate to the child in the photograph. What they see in their minds' eye is their perfect child, not necessarily the same child who was just photographed.

Another issue is that kids, especially little ones, are easily frightened. Therefore, extra care must be taken to provide a safe, fun, working environment. The photographic experience must, in and of itself, be enjoyable for the child. One key is understanding that while adults can control their environment, children cannot. According to Stacy Bratton, a veteran children's photographer and somewhat of an expert on sensory input, "Children cannot identify that the air conditioner in your studio (which is very quiet to most people) is scaring them, they simply start fidgeting or crying or staring into space."

THE REWARDS

George Eastman, the great grandfather of the Eastman Kodak Company, once said that there are about 160 things that can go wrong in the taking of a picture. Clearly, he wasn't talking about child's portraiture—because there are easily double that number of things that can go wrong in the typical child's sitting. But if children's portraiture were *that* impossible, then there wouldn't be so many children's photographers in the world. There are many rewards for excelling at this special skill. One successful children's photographer says that photographing children gives him an opportunity to be a kid himself, almost as if the process were an extension of his not yet being grown up. There is no doubt that the opportunity to enjoy the innocence of children—over and over again—is appealing.

Australian photographer Suzette Nesire, who is extremely well regarded at home and now abroad, says about her work on her website, "I remember years ago Mum saying you don't own your children, they're only on loan. As a photographer I feel there is nothing more important than capturing your little ones and their early years—their faces, their expressions, their little hands and their habits that constantly change. A portrait of your young child is a priceless reminder of a time that once passed and will never return again. Choose to make an investment in a portrait of your child, as pictures convey so much more than words can ever express."

Portraits like this transcend the parents' historical record of a child's growth and are, instead, works of art. This image conveys universal truths about a child's innate innocence and beauty and should represent the level to which all children's portrait photographers aspire. Photograph by Drake Busath.

1. CAMERA TECHNIQUE

Most of today's finest children's portrait photographers use 35mm-format digital SLRs (DSLRs). The predominance of medium and large formats has gone away almost entirely, due to the popularity and flexibility of the DSLR.

LENSES

The rule of thumb for selecting an adequate portrait focal length is to choose one that is twice the diagonal of the format you are using. For instance, with a full-frame sensor (equal to a 35mm film frame), a 75 to 85mm lens is usually a good choice.

With sensors smaller than 24x36mm, all lenses get effectively longer in focal length. This is not usually a problem where telephotos and telephoto zooms are concerned as the maximum aperture of the lens doesn't change, but when your expensive wide-angles or wide-angle zooms become significantly less wide on the digital camera body, it can be somewhat frustrating. A 17mm lens, for example, with a 1.5X lens focal length factor becomes a 25mm lens. A 50mm lens on a camera with a 1.6X focal length factor becomes an 80mm lens.

LEFT—This photo by Judy Host was made with a Fujifilm Finepix S3 Pro and an 80–200mm f/2.8 Nikkor zoom. The filter factor converted the 200mm lens to a 300mm lens and the effect resulted in a softened background because of diminished depth of field.

FACING PAGE—When your subject is a toddler, using a short telephoto is helpful because it provides a greater working distance from camera to subject. Here, Deborah Lynn Ferro used a zoom lens at 90mm to create good perspective and separation from the background. Deborah's taking aperture was f/8, providing enough depth of field to keep the chair, the child, and the outfit all in focus.

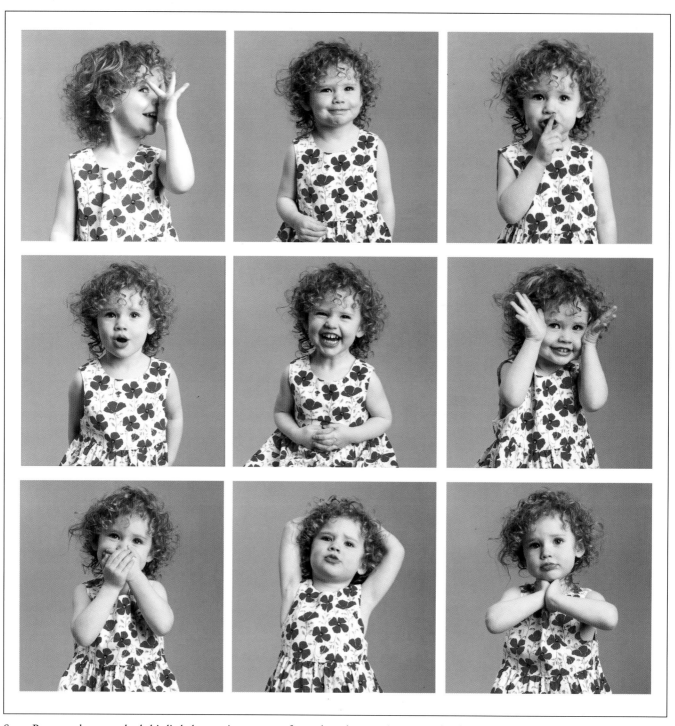

Stacy Bratton photographed this little beauty in an array of moods and poses. Stacy says that her special talent is not taking pictures, although she has extensive training and experience, it's "being able to get a two-year-old who walks in the door, kicks me in the shin and says, 'No!' to everything I'd like them to do, to cooperate fully and hug me and love me—that's my talent."

Fortunately, camera manufacturers who have committed to smaller chip sizes have started to introduce lens lines specifically designed for digital imaging. With these lenses, the circle of coverage (the area of focused light falling on the film plane or digital-imaging chip) is smaller and more collimated to compensate for the smaller chip size. Thus, the lenses can be made more economically and smaller in size, yet still offer as wide a range of focal lengths as traditional lenses.

The Normal Lens. When making three-quarter- or full-length portraits, it is advisable to use the normal focal-length lens (35mm to 50mm, depending on the camera's sensor size, as noted above). Because of a child's size, a three-quarter- or full-length portrait of a child re-

quires that you work much closer to the subject than you would for an adult's portrait. This "normal" lens will provide an undistorted perspective when working at these distances.

The only problem you may encounter is that the subject may not separate visually from the background with the normal lens. It is desirable to have the background slightly out of focus so that the viewer's attention goes to the child, rather than to the background. With a normal and shorter focal-length lenses, depth of field is slightly increased, so that even when working at wide lens apertures, it may be difficult to separate subject from background. This is particularly true when working outdoors, where patches of sunlight or other distracting background elements can easily draw your eye away from the subject.

Fortunately, in the digital age, it is a fairly simple task to diffuse background elements later in post-processing.

The Short Telephoto. In adult portraiture, a longer-than-normal lens maintains accurate perspective. Since children are much smaller than adults, a normal lens or slightly longer-than-normal zoom-lens setting has the same effect as a telephoto lens in adult portraiture. A short telephoto can, however, provide a greater working distance, which can be useful when photographing children. It will also further soften the background due to its inherent reduced depth of field.

Longer Telephotos. You can use a much longer lens if you have the working room. A 200mm lens or the very popular 80–200mm f/2.8 (made by both Nikon and Canon) zoom, for instance, is a beautiful portrait lens because it provides very shallow depth of field and allows the background to fall completely out of focus, providing a backdrop that won't distract from the subject. Such lenses also provide a very narrow angle of view. When used at large apertures, this focal length provides a very shallow band of focus that can be used to accentuate just the eyes, for instance, or just the frontal planes of the child's face. The flexibility of the 80–200mm zoom allows you to vary the focal length to intermediate settings, such as 105mm or 120mm, so that you can achieve correct perspective as well as good background control and composition.

You should avoid using extreme telephotos longer than 300mm for several reasons. First, the perspective becomes distorted and features start to appear compressed.

Depending on the working distance, the nose often looks pasted onto the child's face and the ears of the subject appear parallel to the eyes. Secondly, you must work far away from the child with such a lens, making communication next to impossible. You want to be close enough that you can converse normally with the child.

There will be times when your close presence is annoying the child. In these cases, an assistant may play the role of "good cop," while the long telephoto removes you from the immediate situation.

FOCUSING

Focal Point. In a head-and-shoulders portrait it is important that the eyes and frontal planes of the face be tack

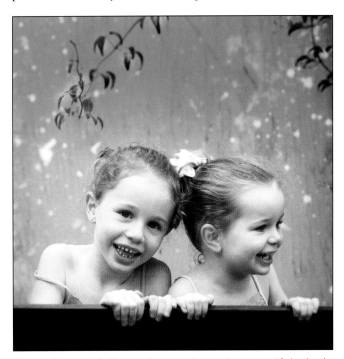

Always focus critically on the eyes. It won't matter if the background is sharp, or in this case the hands—only the eyes matter. Almost everything else is irrelevant. Photograph by Suzette Nesire.

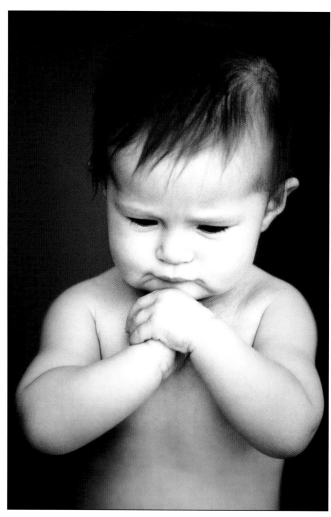

Autofocus, especially multi-zone autofocus, is an invaluable tool in photographing kids who move quickly and unpredictably. Photograph by Suzette Nesire.

When the subject's face is at an angle to the camera, the eyes are not parallel to the image plane. In this case, you may have to split focus on the bridge of the nose to keep both eyes sharp—particularly at wide lens apertures.

Focusing three-quarter or full-length portraits is generally easier because you are farther from the subject, where depth of field is greater. Again, you should split your focus halfway between the closest and farthest points that you want sharp in the image. With these portraits, it is still a good idea to work at wide lens apertures to keep your background soft.

Autofocus. Autofocus, once unreliable and unpredictable, is now extremely advanced. Some cameras feature multiple-area autofocus so that you can, with a touch of a thumbwheel, change the active AF sensor area to different areas of the viewfinder (the center or outer quadrants). This allows you to "de-center" your images for more dynamic compositions.

Autofocus and moving subjects used to be an almost insurmountable problem. While you could predict the rate of movement and focus accordingly, the earliest AF systems could not. Now, however, almost all AF systems use a form of predictive autofocus, meaning that the system senses the speed and direction of the movement of the main subject and reacts by tracking the focus of the moving subject. This is an ideal feature for activity-based portraits, where the subject's movements can be highly unpredictable.

A new addition to autofocus technology is dense multi-sensor area AF, in which an array of AF sensor zones (up to 45 at this writing) are densely packed within

sharp. When working at wide lens apertures where depth of field is reduced, you must focus carefully to hold the eyes, ears, and tip of the nose in focus. This is where a good knowledge of your lenses comes in handy. Some lenses have the majority of their depth of field behind the point of focus; others have the majority of their depth of field in front of the point of focus. You need to know how your different lenses focus. Additionally, it is important to check the depth of field with the lens stopped down to your taking aperture, using your camera's depth-of-field preview control.

Your main focal point should always be the eyes, which will also keep the lips (another frontal plane of the face) in focus. The eyes are the region of greatest contrast in the face. This make focusing simple, particularly for autofocus cameras that require areas of contrast on which to focus.

THE POPULARITY OF FAST ZOOM LENSES

With the advent of smaller image sensors, lens and camera manufacturers have the ability to more affordably design and manufacture faster lenses. The preferred f-stop seems to be f/2.8. Slower than that and photographers complain the viewfinder is too dim. Faster than that and the lens is prohibitively expensive to make in the zoom focal lengths. Thus the overwhelming popularity of the 70–200 and 80–200mm f/2.8 zoom lens. Both Canon and Nikon make these focal lengths, and while still on the pricey side, they really perform. Both series of lenses use internal focusing, so the length of the lens does not change in focusing/zooming. Internal focusing also drastically enhances autofocusing speed. These lenses use rare-earth lens elements in the design and can employ state-of-the-art technology, including vibration reduction.

the image frame, making precision focusing much faster and more accurate. These AF zones are user-selectable or can all be activated at the same time for the fastest AF operation.

Image Stabilization. Image-stabilization lenses optomechanically correct for camera movement and allow you to shoot handheld with long lenses and relatively slow shutter speeds. Canon and Nikon, two companies that currently offer this feature in their lenses, offer a wide variety of zooms and long focal-length lenses with image stabilization. If using a zoom, for instance, with a maximum aperture of f/4, you can still shoot handheld wide open in subdued light at $\frac{1}{10}$ or $\frac{1}{15}$ second and get dramatically sharp results. You can also use the light longer in the day and still shoot with higher-quality ISO 100 and 400 speed settings.

APERTURE

Depth of Field. Telephoto lenses have less depth of field than shorter lenses. This is why so much attention is paid to focusing telephotos accurately. The closer you are to your subject, the less depth of field you will have. When you are shooting a tight face shot be sure that you have enough depth of field at your working aperture to hold the focus on the important planes of the face.

Shooting Aperture. Choosing the working lens aperture is traditionally a function of exposure level, but it is a matter of preference in many cases. For example, some photographers prefer f/8 to f/11, even though f/11 affords quite a bit more depth of field than f/8. This is often because of the relationship between the subject and the background at various working distances.

Many photographers have strong preferences for certain lens apertures. Some will shoot wide open, even though many lenses—even expensive ones—suffer from spherical aberration at their widest apertures. The wide-aperture preference arises from a desire to create a very

delicate plane of focus, making the point of focus the focal point of the composition.

Other photographers, often traditionalists accustomed to the focus-holding swing and tilt movements of large format cameras, will opt for a small taking aperture that holds every plane of the subject in focus. This preference

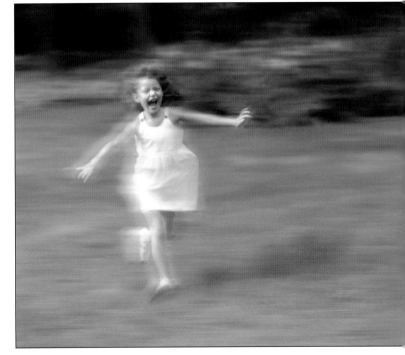

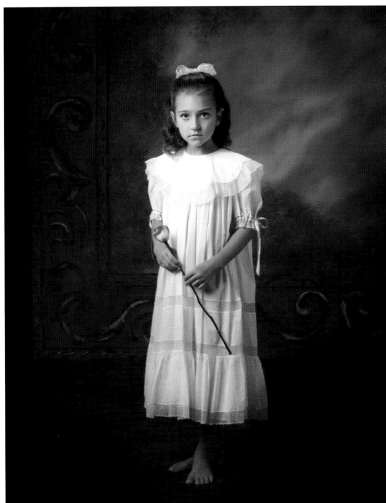

TOP—Panning the camera helped blur the background. A slow shutter speed of $\frac{1}{8}$ second helped blur the edges of the subject. The panning motion kept the subject relatively sharp, since the camera was moving at the same relative speed as the subject. Photograph by Brian Shindle.

RIGHT—When using a normal lens and a camera-to-subject distance that creates a full-length portrait, it is fairly easy to capture the full subject in focus with a relatively wide aperture like f/4 or f/5.6. This elegant studio portrait was made by Brian Shindle.

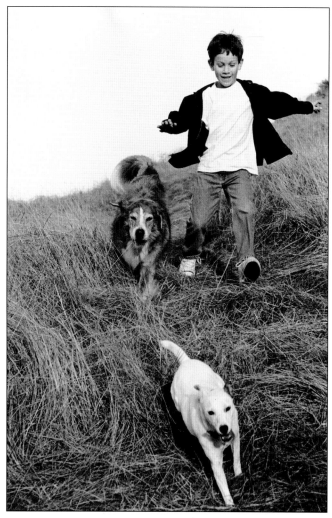

Timing and anticipation are the key ingredients in this great portrait of a boy and his dogs. This is a portrait that every parent would cherish. Janet Baker Richardson made this image with T-Max film and a shutter speed fast enough to freeze the oncoming action. She made sure to hold focus on the boy moving toward her, oblivious to the camera. Janet likes to find what she calls "pockets of pretty light" around clients' homes. Here, she harnessed the weak Southern California morning sunshine, which is often diffused by thin cloud cover overhead.

is most often seen in the studio, where background distance can be controlled, thus limiting the sharpness only to the subject.

There are those, too, who will shoot at the same aperture nearly every time. Why, when there is almost infinite variability to the lens aperture, would one choose the same aperture every time? Because these photographers know that aperture inside and out and can predict the final results—both the region of focus and depth of field—at almost any working distance. It is the predictability that they like.

Optimum Aperture. It is said that the optimum aperture of any lens is $1\frac{1}{2}$ to 2 stops from wide open. This optimum aperture corrects spherical and some chromatic aberrations experienced when the lens is used wide open.

SHUTTER SPEEDS

Your shutter speed must eliminate both camera and subject movement. If you are using available light and a tripod, $\frac{1}{30}$ to $\frac{1}{60}$ second should be adequate to stop average subject movement (the tripod eliminates camera movement).

Outdoors. When working outdoors, you should generally choose a shutter speed faster than $\frac{1}{30}$ second because slight breezes will cause the hair to flutter, producing motion during the moment of exposure.

Handholding. If you are handholding the camera, the general rule of thumb is to select a shutter speed setting that is the reciprocal of the focal length of the lens. For example, if using a 100mm lens, use $\frac{1}{100}$ second (or the next highest equivalent shutter speed, like $\frac{1}{125}$) under average conditions. If you are very close to the subject, as you might be when making a head-and-shoulders portrait, you will need to use a faster shutter speed (higher image magnification requires this). When farther away from the subject, you can revert to the reciprocal shutter speed.

Moving Subjects. When shooting moving children, use a faster shutter speed and a wider lens aperture. It's more important to freeze your subject's movement than it is to have great depth of field for this kind of photo. If you have any doubts about the right speed to use, always use the next fastest speed to ensure sharper images.

With Flash. If you are using electronic flash and a camera with a focal-plane shutter, you are locked into the X-sync speed your camera calls for. With focal plane shutters, you can always use flash and a slower-than-X-sync shutter speed, a technique known as "dragging the shutter," meaning to work at a slower-than-flash-sync speed to bring up the level of the ambient light. This effectively creates a flash exposure that is balanced with the ambient-light exposure.

2. DIGITAL CONSIDERATIONS

Perhaps the greatest advantage of shooting digitally is that when the photographer leaves the event or shooting session, the images are already in hand. Instead of scanning the images when they are returned from the lab, the originals are already digital and ready

to be brought into Photoshop for retouching or special effects and subsequent proofing and printing. The instantaneous nature of digital even allows photographers to put together a digital slide show almost instantaneously. Additionally, digital offers photographers great options when shooting—from frame to frame, you can switch your ISO and white balance, or even switch to shooting in black & white. In this chapter, we'll look at these considerations, and many others.

LCD PLAYBACK
The size and resolution of the camera's LCD screen are important, as these screens are highly useful in determining if you got the shot or not. LCD screens range from about 1.8 inches to 2.5 inches and screen resolution ranges from around 120,000 dots to 220,000 dots. As important as the physical specifications of the LCD is the number of playback options available. Some systems let you zoom in on the image to inspect details. Some let you navigate across the image to check different areas of the frame in close-up mode. Some camera systems allow you a thumbnail or proof-sheet review of captured images. Some of the more sophisticated systems offer histogram (to gauge exposure) and highlight point display to determine if highlight exposure is accurate throughout

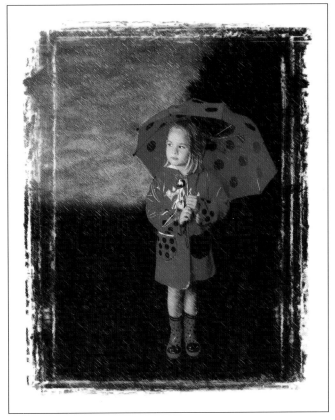

A new red slicker with matching umbrella and boots is more than enough reason to have a special portrait made. Deborah Ferro created this lovely image in studio and later added "digital rain," an almost cartoon-like feature, and a Polaroid border treatment for a very special image.

TOP—Tim Kelly is not only a fine artist, but an equally fine technician. A believer that digital was an inevitability, Tim is obsessed with perfect exposures, saying, "Exposure is everything. In digital, exposure must be more perfect than ever." When exposure is critically perfect, the file reveals great detail and an amazingly wide dynamic range. Each Tim Kelly portrait is retouched digitally with the goal being a timeless and unforgettable portrait.

BOTTOM—Even thought this image looks like it was taken on daylight film under tungsten lighting, it was actually made digitally with a custom white balance setting. The photographer used bounce flash and set the white balance to shade, which is about 7500°K, warming up the image. Photograph by Anthony Cava.

the image. Both features are highly useful, especially when specific detail is needed in the final image, like the highlight detail of a white christening dress.

BATTERY POWER

Since you don't need motorized film transport, there is no motor drive or winder on DSLRs, but the cameras still look the same because the manufacturers have ingeniously designed the auxiliary battery packs to look just like a motor or winder attachment. While most of these cameras run on AA-size batteries, it is advisable to purchase the auxiliary battery packs, since most systems (especially those with CCD sensors) chew up batteries like jelly beans. Most of the auxiliary battery packs for DSLRs use rechargeable Lithium-ion batteries.

CAMERA SETTINGS

ISO. Digital ISO settings correlate precisely to film speeds—the slower the ISO, the less noise (the digital equivalent of grain) and the more contrast. Unlike film, however, contrast is a variable you can control at the time of capture or later in image processing (if shooting RAW files). Digital film speeds can be increased or decreased between frames, making digital capture inherently more flexible than shooting with film, where you are locked into a film speed for the duration of the roll of film.

Shooting at the higher ISOs, like ISO 800 or 1600, produces a lot of digital noise in the exposure. However, many digital image-processing programs contain noise-reduction filters that automatically function to reduce this problem. Products, such as Nik Multimedia's Dfine, a noise reducing plug-in filter for Adobe Photoshop, effectively reduce image noise post-capture.

Contrast. As mentioned earlier, professional-grade DSLRs have a setting for contrast. Most photographers

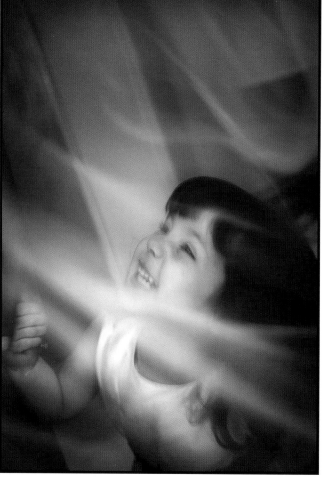

keep it on the low side at capture, because it is much easier to increase contrast after the shoot than to reduce it.

Black & White. Some digital cameras offer a black-and-white shooting mode. Others do not. Most photographers find the mode convenient, since it allows them to switch from color to black and white in an instant. Of course, the conversion is easily done later in Photoshop.

White Balance. White balance is the camera's ability to produce correct color when shooting under a variety of different light sources, including daylight, strobe, tungsten, fluorescent, and mixed lighting. DSLRs have a variety of white-balance presets, such as daylight, incandescent, and fluorescent. Some have the ability to dial in specific color temperatures in Kelvin degrees. Most DSLRs also have a provision for a custom white balance, which is essential in mixed light conditions, most indoor available-light situations, and with studio strobes.

Choosing an accurate white-balance setting is particularly important if you are shooting highest-quality JPEG files (see pages 24–25 for more on file formats). It is not as important if shooting in RAW file mode, since RAW file processors include an extensive set of adjustments for white balance.

Color Space. Many DSLRs allow you to shoot in Adobe RGB 1998 or sRGB color space. There is considerable confusion over which is the "right" choice, as Adobe RGB 1998 is a wider gamut color space than sRGB. Photographers reason, "Why shouldn't I include the maximum range of color in the image at capture?" Others reason that sRGB is the color space of inexpensive point-and-shoot digital cameras and not suitable for professional applications.

The answer is clearer after reading excerpts from a white paper issued by Fujifilm, which recommends the following:

Stay inside the sRGB color space by capturing and working in the sRGB gamut. If the photographer's camera allows the "tagging" of ICC profiles [color profiles for devices, including cameras, monitors, and printers] other than sRGB, we recommend selecting the sRGB option for file creation. The native color space of many professional digital cameras is sRGB, and Fujifilm recommends the sRGB option as the working space for file manipulation when using Adobe

WALLACE EXPODISC
An accessory that digital pros swear by is the Wallace ExpoDisc (www.expodisc.com). The ExpoDisc attaches to your lens like a filter and provides perfect white balance and accurate exposures whether you are shooting film or digitally. The company also makes a Pro model that lets you create a warm white balance at capture. Think of this accessory as a meter for determining accurate white balance, crucial for digital imaging.

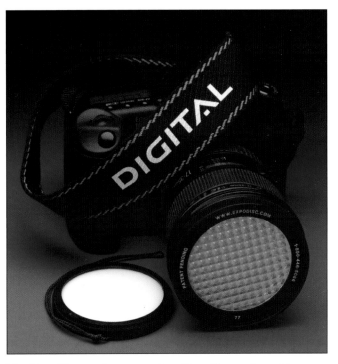

The ExpoDisc attaches to your lens like a filter and provides accurate white balance and exposure readings. It works for both film and digital.

Photoshop along with a fully calibrated monitor. End users/photographers who alter the color space of the original file by using a space other than sRGB, without being fully ICC-aware, are actually damaging the files that they submit to their labs.

There is also another school of thought. Many photographers who work in JPEG format use the Adobe 1998 RGB color space all the time—right up to the point when files are sent to a printer or out to the lab for printing. The reasoning is that, since the color gamut is wider with Adobe 1998 RGB, more control is afforded. Claude Jodoin is one such photographer who works in Adobe 1998 RGB, preferring to get the maximum amount of color information in the original file, then edit the file

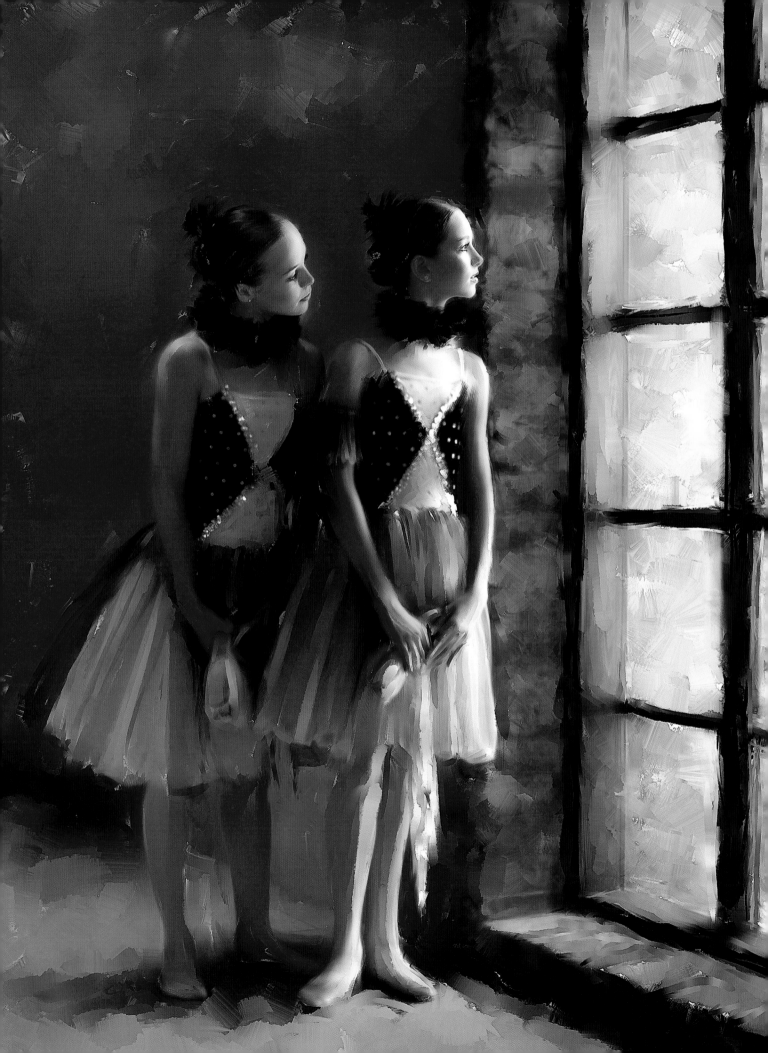

using the same color space for maximum control of the image subtleties.

EXPOSURE

Latitude. When it comes to exposure, digital is not nearly as forgiving as color negative film. The latitude is simply not there. Most digital photographers compare shooting digital (JPEGs) to shooting transparency film, in which exposure latitude is usually ±½ stop or less.

With transparency film erring on either side of correct exposure is bad. When shooting digitally, exposures on the underexposed side are still salvageable, while overexposed images—images where there is no highlight detail—are all but lost forever. You will never be able to restore the highlights that don't exist in the original exposure. For this reason, most digital images are exposed to ensure good detail in the full range of highlights and midtones and the shadows are either left to fall into the realm of underexposure or they are "filled in" with auxiliary light or reflectors to ensure adequate detail.

Evaluating Exposure. There are two ways of evaluating the exposure of a captured image: by judging the histogram and by evaluating the image on the camera's LCD screen. By far, the more reliable is the histogram, but the LCD monitor provides a quick reference for making sure things are okay—and particularly if the image is sharp.

The histogram is a graph that indicates the number of pixels that exist for each brightness level in an individual image. The range of the histogram represents 0 to 255 steps from left to right, with 0 indicating "absolute" black and 255 indicating "absolute" white.

The histogram gives an overall view of the tonal range of the image and the "key" of the image. A low-key image has its detail concentrated in the shadows (a high number of data points near the 0 end of the scale). A high-key image has detail concentrated in the highlights (a high number of data points near the 255 end of the scale). An average-key image has detail concentrated in the mid-tones. An image with a full tonal range has a high number of pixels in all areas of the histogram.

In an image with a good range of tones, the histogram will fill the length of the graph (i.e., it will have detailed

MORE ON COLOR SPACE

Is there ever a need for other color spaces? Yes. It depends on your particular workflow. For example, all the images you see in this book have been converted from their native sRGB or Adobe 1998 RGB color space to the CMYK color space for photomechanical printing. As a general preference, I prefer images from photographers be in the Adobe 1998 RGB color space as they seem to convert more naturally to CMYK.

Ironically, if you go into Photoshop's color settings mode and select U.S Pre-press Defaults, Photoshop automatically makes Adobe RGB 1998 the default color space. Out of the box, Photoshop's default color settings are for the Web, which assumes an sRGB color space, and color management is turned off.

THE TEAM APPROACH

While children's portraiture takes unending amounts of patience and skill, it also takes an extraordinary amount of timing and teamwork. If you pursue this specialty, you will eventually come to the conclusion that one pair of eyes and hands is not enough—it takes a team to effectively photograph children. Sometimes it even takes you, your assistant, *and* the child's mother to make things work.

Often, a husband and wife act in concert to create children's portraits. One will be the "entertainer," using props and a soothing voice, stimulating the child to look alert and in the right direction for the camera. The other will be the technician, making the images, adjusting lighting, camera settings and composition, and trying to be as unobtrusive as possible. The "entertainer" works at getting the child's attention without overstimulation, which often brings the session to a screaming (literally) halt.

shadows and highlights and everything in between). Detailed highlights will fall in the 235–245 range; detailed blacks will fall in the 15–30 range. A histogram representing good exposure will expand to the full range—but without it going off at the ends of the scale.

Overexposure is indicated when data goes off the right end of the graph, which is the highlight portion of the histogram. This means that the highlights are lacking image detail, tone and color. In a properly exposed image, the data on the right side of the graph almost reaches the end of the scale but stops a short distance before the end.

When an image is underexposed, the information in the histogram falls short of the right side and bunches up

FACING PAGE—Bruce Dorn, noted filmmaker turned portrait and wedding photographer, created this beautiful image of two young ballet dancers. The image was digitally captured and then worked in Painter and Photoshop. Brush strokes cover every square of the image, layer upon layer, with minimal intrusion on the faces. The effect is beautiful.

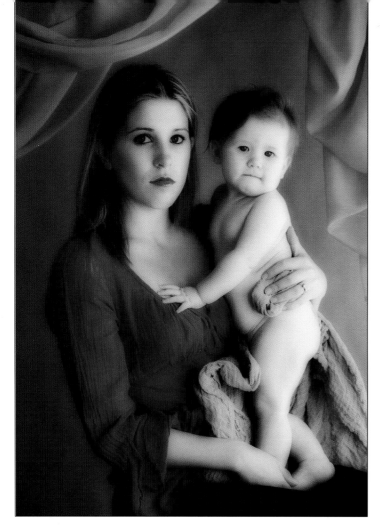

on the left side. Although it is true that an underexposed image is preferable to an overexposed one, nothing will ever look as good as a properly exposed image. You can correct for underexposure in Photoshop's Levels or Curves adjustments, but it is time-consuming to adjust exposure in this manner.

METERING

Reflectance Meter. Because exposure is critical for producing fine portraits, it is essential to meter the scene properly. Using an in-camera light meter may not always provide consistent and accurate results. Even with sophisticated multi-pattern in-camera reflectance meters, brightness patterns can sometimes influence the all-

LEFT—This amazing portrait by Jennifer George Walker has all the elements of great art, including complexity and a sense of uncertainty that makes the viewer contemplative. Aside from its great composition and light, it has been masterfully diffused to soften the edges of everything, idealizing the baby and young mother. The trick with selective diffusion is knowing how far to go.

BELOW—Digitally captured portraits like this one can be taken right away into programs such as Photoshop and Painter for artistic interpretation. Here a combination of Photoshop's filters and Painter's ability to apply brush strokes to the photograph have created a painterly masterpiece. Photograph by Deborah Lynn Ferro.

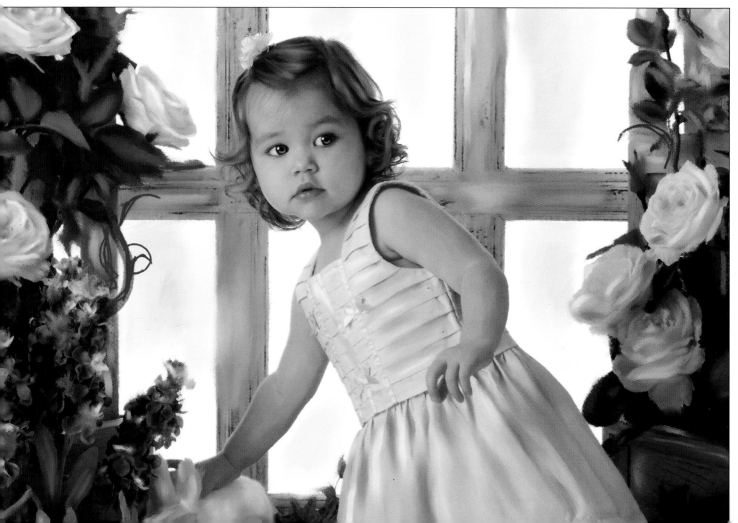

important skin tones. The problem arises from the meter's function, which is to average all of the brightness values that it sees to produce a generally acceptable exposure. Essentially, the in-camera meter wants to turn everything it sees into 18-percent gray, which is dark even for well suntanned or dark-skinned people. If using the in-camera meter, take a meter reading from an 18-percent gray card held in front of the subject. The card should be large enough to fill most of the frame. If using a handheld reflected-light meter, do the same thing—take a reading from an 18-percent gray card or a surface that approximates 18-percent reflectance.

Incident Light Meter. The preferred type of meter for all types of portraiture is the handheld incident light meter. This meter does not measure the *reflectance of the subjects* but determines the *amount of light falling on the scene*. In use, stand where you want your subjects to be, point the hemisphere (dome) of the meter directly at the camera lens, and take a reading. This type of meter yields extremely consistent results, because it is less likely to be influenced by highly reflective or light-absorbing surfaces. (*Note:* If metering a backlit scene with direct light falling on the subject, shield the meter's dome from the backlight. The backlight will influence the exposure reading and your priority should be the frontal planes of the face.)

Incident Flashmeter. The ultimate incident meter is the handheld incident flashmeter, which also reads ambient light. There are a number of models available, but they all allow you to meter both the ambient light and the flash output at the subject position.

The problem is that you either need to have an assistant trip the strobe for you while you hold the meter, or have the subject hold the meter while you trip the strobe to get a reading. You can also attach a PC cord to the meter and trigger the strobe that way, but PC cords can be problematic—particularly when there are children running around.

One solution is to fire the strobe remotely with a wireless triggering device. These devices use transmitters and receivers to send signals to and from the flash or flashes that are part of the system. There are several types of wireless triggering devices. Optical slaves work with bursts of light, such as that from a single electronic flash. The other lights, equipped with optical receivers, sense the pulse of the electronic flash and fire at literally the same time. Radio slaves send radio signals in either ana-

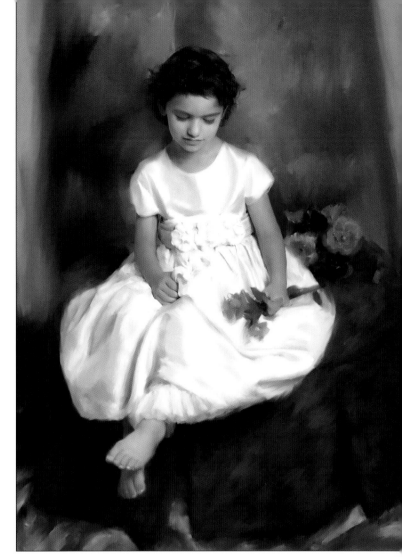

Large digital files can be made to resemble fine artwork in programs like Corel Painter. This image by Deanna Urs was worked extensively in Painter with various brushes and techniques, softening and blending some areas, intensifying others. The result is very much like a fine oil painting. When printed large and framed in a gold ornate frame, the result is impressive. Equally impressive is a close inspection of the details of this image.

log or digital form. Digital systems can be used almost anywhere and they aren't adversely affected by local radio transmissions. For a completely wireless setup you can use a separate wireless transmitter for the handheld camera meter. This allows you the ultimate freedom in cordless metering, since you can meter the ambient and flash exposures from the camera position without the need of an assistant or PC cord. The unit wirelessly fires the flash (or multiple flashes) in a similar manner to the transmitter on the camera.

In order to minimize the number of cords traversing the set—a danger not only to small children but harried photographers—many photographers opt for the wireless triggering of all their studio lights.

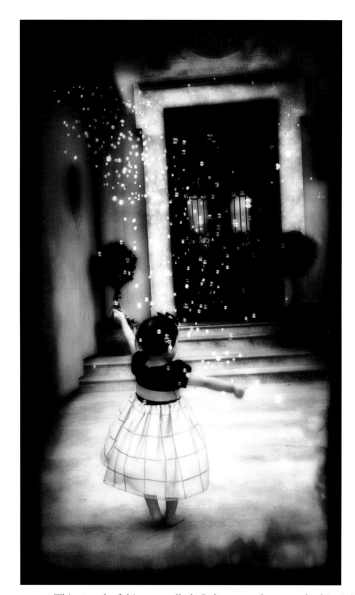

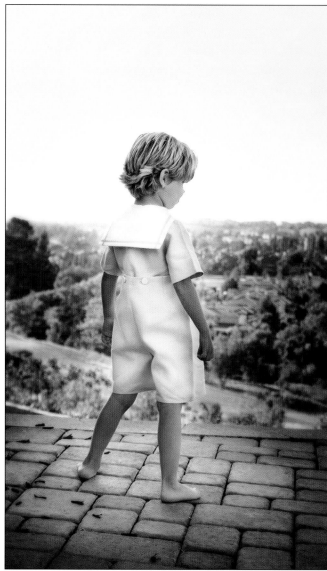

LEFT—This wonderful image called *Galaxy* was photographed in RAW camera mode and processed in Adobe Camera Raw, with minor adjustments, including a tonal alteration. The photographer then enhanced the image in Photoshop. Photograph by Kersti Malvre.

RIGHT—For Kersti Malvre, digital is an extension of her creativity that allows her to push the art form further. But she likes to maintain the integrity of a photographic image rather than manipulating it into something too wild. She says, "I can explore all the possibilities of color and mood and access all the incredible creative choices that Photoshop offers."

Spotmeter. A good spotmeter is a luxury for most photographers. It is an invaluable tool, especially if you are working outdoors. The value of a spot meter is that you can use it to compare exposure values within the scene, something you can't do as critically with an incident meter. For example, you can look at the highlights in your subject's hair, which may be illuminated by sunlight and compare that reading to the exposure on the subject's face, which may be illuminated by a reflector. If the hair is more than two stops brighter than your exposure, you will know that you need to adjust one or the other to maintain good detail in both areas. Similarly, in the studio, you can use the spotmeter to check on the values created by various lights, reading them individually or collectively.

FILE FORMAT

DSLRs offer the means to shoot in several modes, but the two most popular ones are JPEG and RAW. Each mode has some advantages and drawbacks.

JPEG. Shooting in the JPEG Fine mode (sometimes called JPEG Highest Quality) creates smaller files, so you can save more images per CF card or storage device. The smaller file size also allows you to work much faster.

However, your options for correcting the image after the shoot aren't as powerful as with a RAW file. JPEG is also a "lossy" format, meaning that the images are subject to degradation by repeated opening and closing. Most photographers who shoot in JPEG mode either save the file as a JPEG copy each time they work on it, or save it to a "lossless" TIFF format, so it can be saved again and again without degradation.

RAW. RAW files offer the benefit of retaining the highest amount image data from the original capture. This gives you the ability to almost completely correct for underexposure.

RAW files also contain more data than JPEG files, which feature some level of compression. As a result, if you need faster burst rates, RAW files will slow you down (although new cameras with bigger buffers—and buffer upgrades for existing cameras—have improved the situation greatly). RAW files will also fill up your storage cards or microdrives more quickly than JPEGs.

Shooting in the RAW mode requires the use of RAW file-processing software that translates the file information and converts it to a useable format. Only a few years ago RAW file-processing software was limited to the camera manufacturer's software, which was often slow and difficult to use. With the introduction of independent software like Adobe Camera RAW and Phase One's Cap-

ture One DSLR, RAW file processing is not nearly as daunting.

METADATA

DSLRs give you the option of tagging your digital image files with data, which often includes the image's date, time, and camera settings. To view this information in Photoshop, go to File > File Info and look at the EXIF data in the pull-down menu. Here, you will see all of the data that the camera automatically tags with the file. You

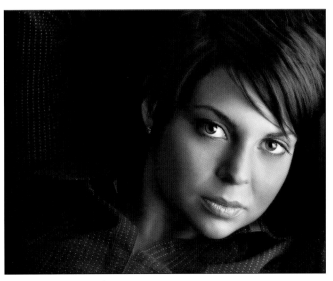

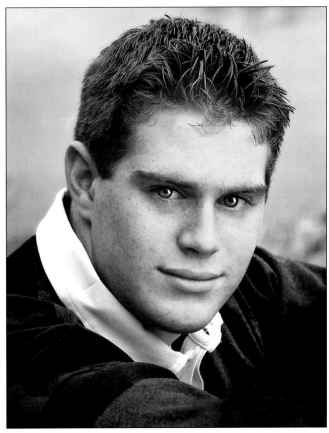

TOP—Tim Schooler always uses a large softbox (4x6 feet) for his main and accent lights. Of his image treatments, he says, "I am not a fan of over-softening skin, I think it is done too much these days. But with digital, and the high-resolution sensors we're using now, you have to do a subtle amount of diffusion to take the edge off. But I still want to see detail in the skin, so I'll apply a slight level of diffusion on a layer, then back if off until I can see skin pores. I have Capture One set for high contrast skin tones, and 7-percent increase in color saturation that gives my finished images a little more color. Seniors seem to like it. My goal is to shoot everything as a finished image. In fact, that's how I proof. Nothing is edited or retouched before the client sees it. Then we retouch only what they ask for."

BOTTOM—Tim Schooler shoots all his senior images in RAW mode, using Phase One's Capture One, which has four options to emulate "the look" of film. Tim uses a custom profile from Magne Nielson for skin tones. In Capture One, you can set the default film type to Linear Response, Film Standard, Film Extra Shadows or Film High Contrast. Tim says, "I used to use film standard but found I was tweaking the curves for a bit more punch in Photoshop. Now I use film high contrast and I find its a lot closer to Kodak Portra VC, which was my preferred film type before we went digital."

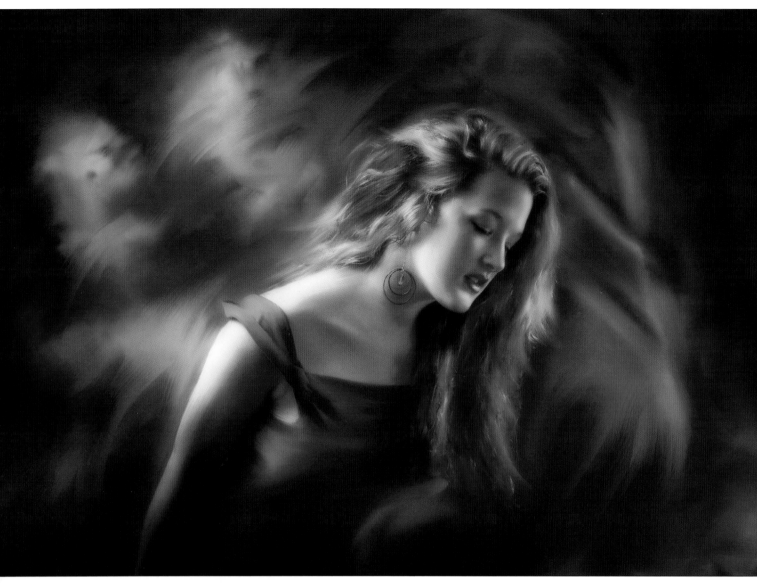

Craig Kienast often merges his backgrounds and subjects, which are often the same tones, in Painter and creates an entirely different portrait than was originally captured.

can also add your copyright notice to this data, either from within Photoshop or from your camera's metadata setup files. Adobe Photoshop supports the information standard developed by the Newspaper Association of America (NAA) and the International Press Telecommunications Council (IPTC) to identify transmitted text and images. This standard includes entries for captions, keywords, categories, credits, and origins from Photoshop.

REFORMAT YOUR CARDS

After you backup your original files to a least two sources, it's a good idea to erase all of the images and then reformat the CF cards. It isn't enough to simply delete the images, because extraneous data may remain on the card, possibly causing data interference. After reformatting, you're ready to use the card again.

3. STUDIO LIGHTING

When kids are photographed in the studio, the lighting setups you use should be simplified for active subjects and short attention spans. Elaborate lighting setups that call for precise placement of backlights, for example, should be avoided in favor of a

single broad backlight that creates an even effect over a wider area. In fact, when photographing children's portraits, if one light will suffice, don't complicate the session. Simplify!

THREE DIMENSIONS AND ROUNDNESS
A photograph is a two-dimensional representation of a three-dimensional subject. It is, therefore, the job of the portrait photographer to show the contours of the subject—and particularly the face. This is done with highlights and shadows. Highlights are areas that are illuminated by a light source; shadows are areas that are not. The interplay of highlight and shadow creates roundness and shows form. Just as a sculptor molds clay to create the illusion of depth, so light models the shape of the face to give it depth and form.

QUALITY OF LIGHT
Light can be sharp and specular or soft and gentle. Which quality a given light source will display is a function of its size in relation to the subject.

Size of the Source. Small, undiffused light sources produce light that is crisp with well-defined shadow areas and good rendering of texture. These sources can create a portrait that is quite dramatic. Large light sources, on the other hand, produce a smoother, more gentle look

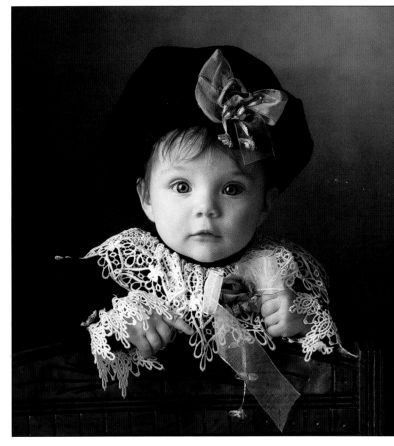

Tim Kelly is a master of lighting and, like the great portraitists throughout history, he creates light that seems to emanate from within the portrait. His standard tools are large softboxes, strip lights for hair and the background, and reflectors everywhere. This remarkable portrait, titled *To the Nines*, is a home run.

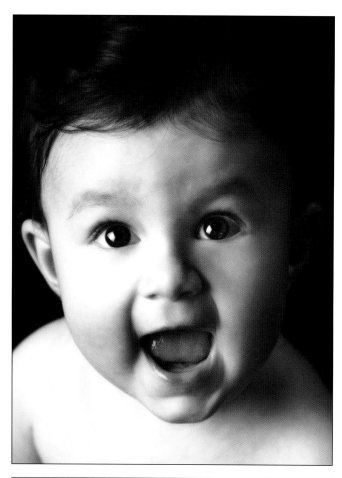

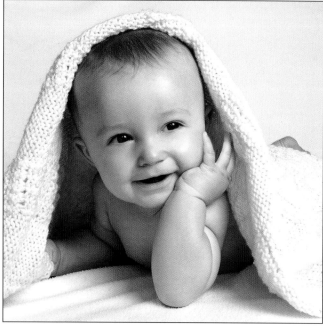

TOP—The proximity and size of the light controls its softness. Here Kevin Jairaj used a very large softbox close to the baby and silver reflectors on the floor beneath the set. The light still has dimension and creates a pleasant cross lighting pattern because it is positioned to the side and almost behind the child. The child is delighted by whatever sound Kevin is making.

BOTTOM—Here is a delightful two-light portrait by David Bentley. The main light, a large softbox, is to camera right, and a less powerful softbox is used just on the other side of the camera and close to the camera/subject axis. The lighting ratio is a very pleasing 3:1. A similar effect can be achieved with a single soft light and a large reflector.

placed at a distance can begin to produce a more specular quality of light, despite its inherent size.

Diffused *vs.* Undiffused Light. Undiffused light, like that produced by a parabolic reflector, is sharp and specular in nature. It produces crisp highlights with a definite line of demarcation at the shadow edge. These light sources take a great deal of practice to use well, which is probably why they are not used too much anymore—and especially why they are not used for kids' portraits.

Diffused light sources—softboxes, umbrellas, and strip lights—are much simpler to use because they scatter the outgoing beams of light as they pass through the diffusion material. This bathes the subject in light that is softer and significantly less intense. This makes it a good choice for lighting children's portraits. These bigger light sources also tend to spread the light over a wider area, which is ideal for small, squirmy subjects who can change positions frequently and quickly.

An additional advantage of using diffused light is that, often, you don't need a separate fill light; the highlights tend to "wrap around" the contours of the face. If any fill source is needed, a reflector will usually do the job.

A single softbox will produce beautiful soft-edged light, ideal for illuminating little faces. Softboxes are highly diffused and may even be double-diffused with the addition of a second scrim over the lighting surface. In addition, some softbox units accept multiple strobe heads for additional lighting power and intensity.

Umbrellas, including the shoot-through type, can be used similarly and are a lot easier to take on location than softboxes, which have to be assembled and placed on sturdy light stands with boom arms. Photographic umbrellas are either white or silver. A silver-lined umbrella produces a more specular, direct light than does a matte white umbrella. It will also produce wonderful specular

that is usually considered more flattering for portraits—especially of children.

Distance to Subject. When used close to a subject, however, even a small light source can produce a softer effect with more open shadows than when the same light is used at a distance. Conversely, a large light that is

highlights in the overall highlight areas of the face. Some umbrellas come with intermittent white and silver panels. These produce good overall soft light but with specular highlights. They are often referred to as zebras.

Umbrellas, regardless of type, need focusing. By adjusting the length of the exposed shaft of the umbrella in its light housing you can optimize light output. When focusing the umbrella, the modeling light should be on so you can see how much light spills past the umbrella surface. The umbrella is focused when the circumference of the light matches the perimeter of the umbrella.

It should be noted that the closer the diffused light source is to the subject, the softer the quality of the light. As the distance between the light source and subject increases, the diffused light source looks less like diffused light and more like direct light.

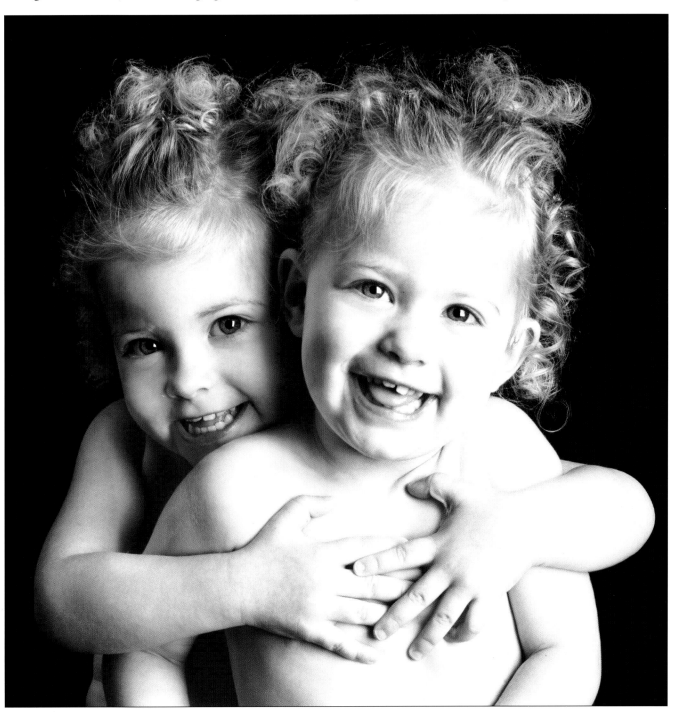

Stacy Bratton created this wonderful portrait of twins using her very large softbox. The light wraps around the face of the forward girl, lighting the second twin—but in order to create a more dramatic lighting ratio, no fill light or reflector was used. Note, too, that Stacy used enough light to produce a healthy depth of field and keep both girls fully sharp.

TIMING

When working with strobes, which have preset recycle times, you cannot shoot as you would under available light—one frame after another. You have to factor in at least these two things: (1) the strobes may startle the child initially, thus curtailing a fun time; and (2) while you're waiting for the flash to recycle, you may see three or four pictures better than the one you just took. Experience and patience are keys in the latter situation; you don't necessarily have to jump at the first opportunity to make an exposure. Here's where working with a trusted assistant can really help, since you can gauge by their activity if the event is building or subsiding. Out of every sequence of possible pictures one will be the best. Assume you'll only get one chance and your patience will often be rewarded. Perhaps the best advice is to always be ready. Preparedness often leads to success.

HYBRID LIGHT

The late Master photographer Don Blair often used a hybrid light—a broad parabolic fill with a barebulb strobe. He noted that the barebulb adds a softness that you cannot get from an umbrella or other diffuser. He preferred it for photographing children because he says it wraps the child in soft, open light.

According to Stacy Bratton, the final image (below) was created from ten different images (right). She never even attempted to take the kids' photos together, reasoning that she could better control the lighting and expressions by photographing smaller groups. The plan did not go smoothly; one little girl decided to put on other costumes and jump into a few shots with the other groups. The lighting is smooth from one end to another because she only photographed five kids at a time. The key light was positioned 45 degrees from camera right. She used a 3x5-foot Plume Wafer softbox with a quad-head Speedotron flash as the main light. Using all 2400 Watt-seconds of available flash power allowed her to achieve an f/16 taking aperture. Stacy uses a specialized lighting system for her kids' portraits. Above the set she has mounted very large white cards (4x16 feet) into which she bounces powerful barebulb flash. In this photo, she used 4800 Watt-seconds! She also uses a small silver reflector directly over the kids to act as a hair light.

LIGHT POSITIONS AND FUNCTIONS

Main Light and Fill Light. The two basic lights used in portraiture are called the main light and the fill light. Traditionally, the main and fill lights were high-intensity lights fitted with either reflectors or diffusers. Polished pan reflectors (also called parabolic reflectors) are silver-coated "pans" that attach to the light housing and reflect the maximum amount of light outward in a focused manner. Most photographers don't use parabolic reflectors anymore, opting for diffused main- and fill-light sources like umbrellas or softboxes. Diffused light sources are ideal for kids because they are large and forgiving, meaning that the child can move around and not move out of the light.

When using a diffused main light source, the fill light source is often a reflector—a portable, highly reflective surface that is used to bounce extraneous light (from the

HYBRID LIGHT

The late Master photographer Don Blair often used a hybrid light—a broad parabolic fill with a barebulb strobe. He noted that the barebulb adds a softness that you cannot get from an umbrella or other diffuser. He preferred it for photographing children because he says it wraps the child in soft, open light.

main light) into the shadows of the face and body of the subject. If using a diffused light source for the fill light, however, be sure that you do not spill light into areas of the scene where it is unwanted, such as the background or the camera's lens.

Hair Light. In a diffused lighting scenario, the hair light for kids' portraits is a smaller diffused light source, usually suspended on a boom and highly maneuverable so that it can just add a subtle highlight to the child's hair and head. Sometimes called striplights, these small softboxes are positioned behind and above the subject, just out of the camera's view.

Background Light. If a background light is used, it is diffused and washes the background with light so that it does not go dull in the final photo.

Kicker Lights. Kickers are optional lights used similarly to hair lights. These add highlights to the sides of the face or body to increase the feeling of depth and richness in a portrait. Kickers are used behind the subject and produce highlights with great brilliance, because the light just glances off the skin or clothing. Since they are set behind the subject, barn doors should be used.

LIGHTING STYLES

Broad *vs.* Short Lighting. There are two basic types of portrait lighting. Broad lighting means that the main light illuminates the side of the face turned toward the camera. Short lighting means that the main light is illuminating the side turned away from the camera.

Broad lighting is used less frequently than short lighting because it flattens and de-emphasizes facial contours.

When using diffused light sources, such as the giant softbox used by Stacy Bratton in both of these shots, the difference between broad and short lighting can be defined by the turn of the head. In these examples, the baby in the crazy knitted hat is showing more of the shadow side of the face, thus it is short lighting; the older girl in overalls is turned away so that the highlight side is more prominent and most visible; thus it is broad lighting. If Stacy had turned her subject's head back towards camera right, it would have turned into a short lighting setup.

Short lighting emphasizes facial contours and can be used as a corrective lighting technique to narrow a round or wide face. When used with a weak fill light, short light-

FEATHERING

Feathering means using the edge, rather than the hot core, of the light source. If you aim a light source directly at your subject, you will find that while the strobe's modeling light might trick you into thinking the lighting is even, it is really very hot in the center, producing an area of blown-out highlights. Feathering will help to even the light across your subject so that you are using the light source's dynamic edge, rather than the hot core of the light. This is achieved by aiming the light past the subject or up and over the subject. Since this means you are using the edge of the light, you have to be careful not to let the light level drop off. This is where a handheld incident flashmeter is of great value. Always verify your lighting with the meter and by testing a few frames.

David Bentley used a single diffused light source positioned very close to his young subject so that the light would wrap around to the shadow side of his face, negating the use of a fill source. In the catchlights, you can see the shape of the light source, which contained multiple strobe heads. You can also see that the photographer feathered the light source to use the more dynamic edge of the light. Bentley is a master at lighting, having learned from some of the great names in portrait photography.

ing produces dramatic lighting with bold highlights and deep shadows.

The Basic Lighting Patterns. Although there are five distinct lighting patterns in traditional portraiture (Paramount, loop, Rembrandt, split, and profile lighting), they are seldom used in children's portraiture because they call for sharper, less diffused light sources. When you use a large, diffused light source—the type of main light usually employed in children's portraiture—its effects will be less visible, since the shadow edge is much softer.

What is important to remember is that you should define a lighting pattern by making the main light stronger than the fill light. The fill is necessary to lighten shadows that go unilluminated, but the most important light is the main light. It is usually positioned above and to one side of the child, producing a corresponding shadow pattern on the side of the child's face opposite the light source. Different effects are achieved by elevating or lowering the main light and moving it to one side of the subject. The lighting patterns are produced by the main light, which only lights the highlight side of the face.

There are a few important things to remember about the position of the main light. When placed high and roughly on the same axis as the subject's nose, the lighting will be nearly overhead. When this occurs, shadows will drop under the nose and chin and, to some extent, the eye sockets. The eyelashes may even cast a set of diffused shadows across the eyes, and the eyes themselves will need a fill source to open up the shadows and to get them to sparkle.

As you move the light lower and farther to the side of the subject, the roundness of the face becomes more evident. There will also be more shadow area visible on the side of the face opposite the main light. As a general rule, most portrait photographers start with the main light roughly 30 to 45 degrees from the camera/subject axis and at a medium height.

Catchlights. Catchlights are small, specular (pure white) highlights that appear on the iris of the eye and make the eyes look alive and vibrant. Without catchlights, subjects often have a vacant, dull appearance. The catchlights you create will be the same shape as your main light source—if using a softbox, the catchlights will be square; when a striplight is used, the catchlights will be rectangular and elongated, and so on. If you use a second light or a reflector that adds light to the eyes, this too will be mirrored in the eyes. This secondary catchlight can be retouched after the shoot for a more natural appearance.

LIGHTING RATIO

The term "lighting ratio" is used to describe the difference in intensity between the shadow side and highlight side of the face in portraiture. It is expressed numerically as a ratio. A ratio of 3:1, for example, means that the highlight side of the face has three units of light falling on it, while the shadow side has one unit of light falling on it. Ratios are useful because they determine how much local contrast there will be on the subject of the portrait.

Since they reflect the difference in intensity between the main light and the fill light, the ratio is also an indication of how much shadow detail you will have in the portrait.

Calculating. There is considerable debate and confusion over the calculation of light ratios. This is principally because your have two systems at work, one arithmetical and one logarithmic. F-stops are in themselves a ratio between the size of the lens aperture and the focal length of the lens, which is why they are expressed as f/2.8, for example. The difference between one f-stop and the next full f-stop is either half the light or double the light. For example f/8 lets in twice as much light through a lens as

This is a beautifully executed portrait of three sisters by Brian Shindle, who used a single large softbox to the left of the camera and a large white reflector to the right of the camera. A diffused hair light was used from above. Brian removed the second set of catchlights in the eyes and reshaped the rectangular catchlights to form a circular pattern, giving the image a more traditional feel.

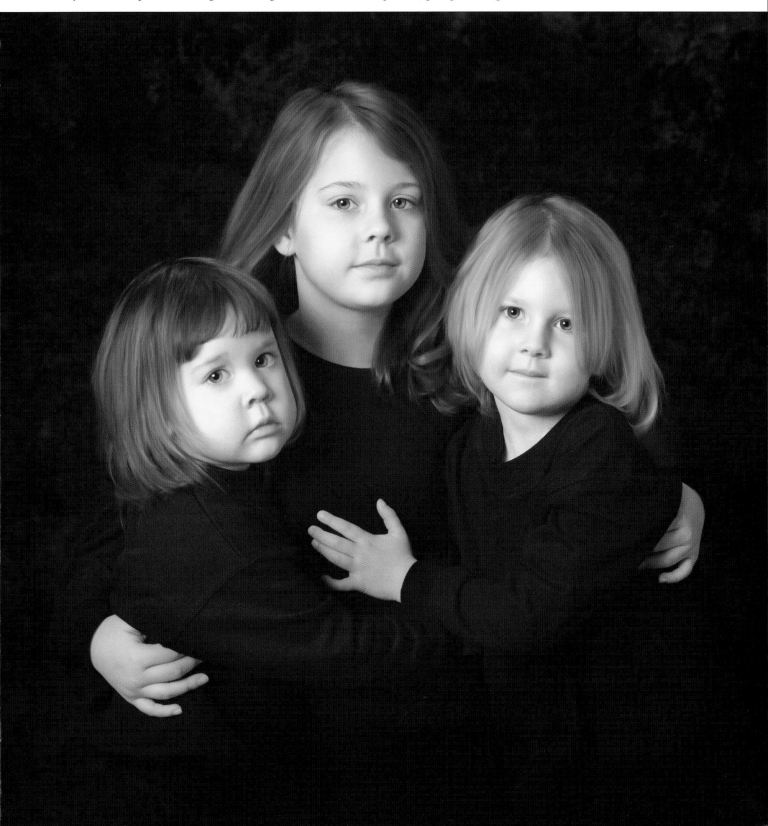

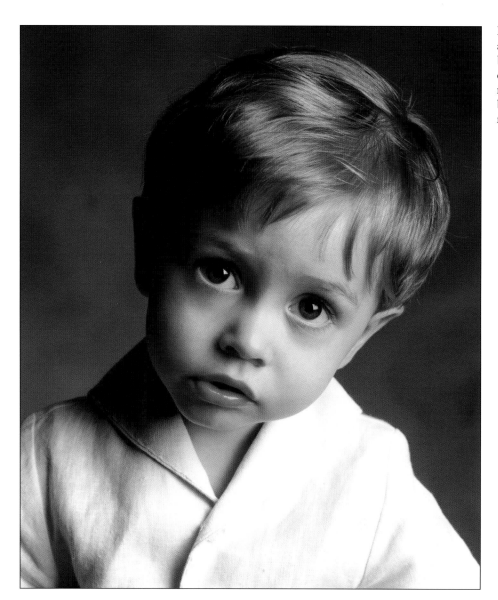

Here, Stacy Bratton used her customary very large softbox off to the side, but with no fill source. The effect is dramatic lighting with a fairly strong ratio of 3.5:1. She also used a small backlight source to give some illumination to the painted backdrop.

f/11 and half as much light as f/5.6. However, when we talk about light ratios, each full stop is equal to *two units* of light. Each half stop is equal to *one unit* of light. This is, by necessity, a suspension of disbelief, but it makes the light ratio system explainable and repeatable.

In portrait lighting, the fill light is always calculated as one unit of light, because it strikes both the highlight and shadow sides of the face. The amount of light from the main light, which strikes only the highlight side of the face, is added to that number. For example, imagine you are photographing a small child and the main light is one stop greater than the fill light. These two lights are metered independently and separately. The one unit of the fill light (because it illuminates both the shadow and highlight sides of the faces) is added to the two units of the main light (which lights only the highlight side of the face), indicating a 3:1 ratio.

Ratios for Children. You will most often see children photographed with low to medium lighting ratios of 2:1 to 3.5:1.

A 2:1 ratio is the lowest lighting ratio you should employ. It shows only minimal roundness in the face. In a 2:1 lighting ratio the main and fill light sources are the same intensity (one unit of light falls on the shadow and highlight sides of the face from the fill light, while one unit of light falls on the highlight side of the face from the main light—1+1=2:1).

A 3:1 lighting ratio is produced when the main light is one stop greater in intensity than the fill light (one unit of light falls on both sides of the face from the fill light, and two units of light fall on the highlight side of the face from the main light—2+1=3:1). This ratio is the most preferred for color and black & white because it will yield an exposure with excellent shadow and highlight detail.

It shows good roundness in the face and is ideal for rendering average-shaped faces.

Stronger ratios are more dramatic, but less appropriate for kids. It should be noted that "corrective" lighting ratios are rarely used with children. With adults who have large or wide faces, a split lighting pattern and a 4:1 ratio will noticeably narrow the face. With children, wide faces are a happy fact of life—they make little subjects look cherubic.

SOME FAVORITE SETUPS

Large Softboxes. Very large light sources—larger than most children—are a popular choice for photographing children. Photographer Brian Shindle uses a big 4x6-foot softbox and a secondary 2x4-foot softbox to wash his small clients in a soft directional light. Stacy Bratton also uses soft large light—primarily a 72x54-inch Chimera softbox with an extra baffle in the middle. She uses it straight on and with the bottom edge parallel to the floor so that the catchlights it produces are square—a unique trademark of her lighting. When used at floor level from the side, these large softboxes simulate the look of window light or light coming through an open doorway. It is an excellent illusion, especially when used on location.

Softbox and Silver Reflector. Another popular children's lighting setup is done with a softbox and silver reflector with the child in a profile pose. The softbox is positioned close to and facing the child. This lights the frontal planes of the face straight on—but because the face is then photographed from the side, the light is ac-

tually skimming the skin's surface. The light is feathered toward the camera so that the edge of the light is employed. A silver reflector, positioned below camera level between the child and the camera is adjusted until it produces the maximum amount of fill-in. (*Note:* It is important to use a lens shade with this type of lighting, because you are feathering the softbox toward the lens. You can, of course, feather the light away from the lens, toward the background, but the shot will be more difficult to fill with the reflector.)

Fran Reisner's Studio. Fran Reisner's in-home studio is the culmination of having many former studios that were deficient in one way or another. Her other studios, most of which were converted garages, had low ceiling height and limited room size and depth. As Fran prefers using long lenses for her children's portraits, plenty of room depth is preferred.

Her current camera room is approximately 20 x 32 feet, allowing her to shoot full-length portraits with long lenses. Her 10-foot ceilings support a rail system for her strobes, eliminating the clutter of light stands and greatly improving her maneuverability.

The studio also has double glass doors and three large windows that provide a wonderful variety of natural-light situations. Since the room faces south, Fran designed the structure with deep eight-foot patios in order to eliminate direct light. When there is direct light, in early mornings during the summer, she usually diffuses it. She says, "I either 'play' with it or simply control it with diffusion material."

 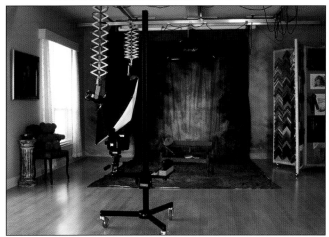

Fran Reisner's studio is a separate structure she had built at the time she built her home outside Dallas. The camera room was designed so that she could use predominantly soft window light, softened by sheers in the windows and double glass doors. Her lights are on tracks mounted on the ceiling, but often she only uses the white reflective surfaces of the softboxes with the strobes extinguished for fill—the wraparound quality of the window light is that effective.

4. OUTDOOR AND NATURAL LIGHTING

Youngsters are often more at ease in natural surroundings than they are in the confines of a studio. Fortunately, outdoor lighting offers countless lighting possibilities. You can photograph children in backlit, sidelit, or frontlit situations; in bright sun or deep

Elizabeth Homan capitalized on some beautiful "found" lighting—late afternoon sun rim lighting the trellis and young girl, and a bright house close by reflecting direct sun back onto the scene. Elizabeth enhanced the portrait by softening the background and painting in details into the flowers in the arbor and greenery.

shade. The ability to control outdoor lighting is really what separates the good children's photographers from the great ones. Learning to control, predict, and alter daylight to suit the needs of the portrait will help you create elegant natural-light portraits consistently.

Just as in the studio, it is important that outdoor images appear to be lit by a single light. This is a fundamental in portraiture. Unlike the studio, where you can set the lights to obtain any effect you want, in nature you must use the light that you find.

COMMON PROBLEMS

One thing you must be aware of outdoors is separating the subject from the background. Dark hair against a dark green forest background will create a tonal merger. Adding a controlled amount of flash fill or increasing the background exposure will solve the problem.

Sometimes, you may choose a beautiful location for a portrait, but find that the background is totally unworkable because of a bald sky, a cluttered look, or mottled patches of sunlight. The best way to handle such backgrounds may be later in post-production. Any number of softening, vignetting, diffusion, or grain effects can be added to the background alone to solve the problem.

You may also encounter excess cool coloration in portraits taken in shade. If your subject is near a grove of

Backlighting puts a beautiful rim of golden light around the subject. The fill light, reflected from nearby cement and structures, is very adequate. The photographer, Judy Host, also diffused the image to lessen the overall contrast.

trees surrounded by foliage, there is a good chance that green will be reflected onto your subject. If your subject is exposed to clear, blue open sky, there may be an excess of cyan in the skin tones. While you are setting up, your eyes will acclimate to the off-color rendering, and the color cast will seem to disappear. To correct this, take a custom white balance reading or set your camera to auto white balance. You can also photograph your session in the RAW mode, then fine-tune the color balance in image-processing to get a completely neutral skin tone rendering.

DIRECT SUNLIGHT

It is important to check the background while composing a portrait in direct sunlight. Since there is considerably more light than in a portrait made in the shade, the

FACING PAGE—In this beautiful portrait by Kersti Malvre, the light is contrasty and overhead in nature. Kersti tilted her subject's head up to fill the shadows and diffused the image in Photoshop to lessen the lighting contrast.

ABOVE—Positioning your subject near an overhang, such as this wall and overhanging ivy, makes the overhead light more frontal in nature. In this lovely portrait by Fran Reisner, the lighting comes from above and to camera right, producing a nice shadow side of the face and attractive lighting ratio.

tendency is to use an average shutter speed like ¹⁄₂₅₀ second with a smaller-than-usual aperture like f/11. Smaller apertures will sharpen up the background and take attention away from your subject. Preview the depth of field to analyze the background. Use a faster shutter speed and wider lens aperture to minimize background effects in these situations.

Backlighting. To take advantage of golden sunlight, turn your subject so they are backlit, or use cross lighting. Backlighting voids the harshness of the light and prevents your subject from squinting. Of course, you need to fill-in the backlight with strobe or reflectors. You also need to be careful not to underexpose. It is really best to use a handheld incident meter in backlit situations, but if you have no meter other than the in-camera one, move in close to take your reading on the subject. In backlit portraits, it is best to give each frame an additional third- to half-stop of exposure in order to open up the skin tones.

Cross Lighting. If the sun is low in the sky, you can use cross lighting, otherwise known as split lighting, to get good modeling on your subject. Position the child so that the light is to the side but almost behind him or her. Almost half of the face will be in shadow while the other half is highlighted. You must be careful to position the subject's head so that the sun's sidelighting does not hollow out the eye sockets on the highlight side of the face. You must also fill in the shadow side of the face. If using flash, the flash exposure should be at least a stop less than the ambient light exposure.

Softening with Scrims. "Scrim" is a Hollywood lighting term used to define a large sheet of mesh or translucent nylon material that diffuses a direct light

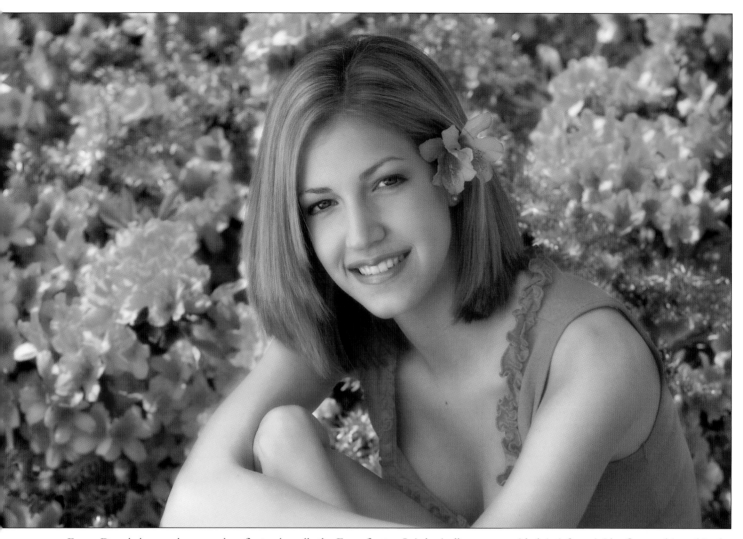

Fuzzy Duenkel uses a homemade reflector he calls the Fuzzyflector. It is basically two two-sided 4x4-foot rigid reflectors hinged in the middle so that the unit will stand up by itself. Because there are four separate sides, they can produce four different levels of reflectivity. A Mylar surface provides a very powerful reflector that can be aimed precisely to act as a main light in bright sun or an edge light from behind the subject. A spray-painted silver surface provides an efficient, color-balanced fill-in at close range. A white surface provides a softer fill, and a black surface can be used for subtractive effects. Here, the reflector was positioned close to Fuzzy's senior subject and bounces the warm backlight, softening it as if the light were coming from a softbox. A gobo is positioned above to keep direct sunlight off the subject.

source. Scrims are often seen on large, portable frames on movie sets. The frame is hoisted into position between the light source and the set and tied off with ropes so that the light is diffused and softened, giving a soft skylight effect.

The same technique can be used with with still photography using large translucent panels, such as the Westcott 6x8-foot panel. If the child is seated on the grass in bright sun, the scrim can be held just overhead by two assistants. The panel would be positioned so that the child and the area just in front of and behind him/her is affected. If shooting at child-height, the background is unaffected by the use of the panel, but the lighting on the child is soft and directional. Usually, the diffusion

panel softens the light so much that no fill source is required.

Flash-Fill. In direct sunlight situations, set your flash at the same exposure as the daylight. The daylight will act as a background light and the flash, set to the same exposure, will act as a main light. If your exposure is $\frac{1}{500}$ second at f/8, for example, your flash output would be set to produce an f/8 on the subject. Use the flash in a reflector or diffuser of some type to focus the light. Position the flash to either side of the subject and elevate it to produce good facial modeling. An assistant or light stand will be called for in this lighting setup. If your strobe has a modeling light, its effect will be negated by the sunlight. Without a modeling light it's a good idea to

check the lighting with test frame and view the results on the LCD.

OVERHEAD LIGHT

Out in the open, mid-day sunlight has an overhead nature that can cause "raccoon eyes"—deep shadows in the eye sockets and under the nose and lower lip. The effects are also visible on cloudy days, although they can be tricky to see.

Blocking Overhead Light. The best light for portraiture is found in or near a clearing in the woods, where tall trees provide an overhang above the subjects, thus blocking the overhead light. In a clearing, diffused light filters in from the sides, producing better modeling on the face. Man-made overhangs, like porches, can produce the same effect. You can also make your own overhang by having an assistant hold a gobo (an opaque or black reflector) over the child's head. This will block the overhead light, allowing light to come in from the sides.

Filling Overhead Light. If shooting under these circumstances, you must fill in the daylight with a reflector or flash. The fill will determine the three-dimensionality of the rendering of the face(s) and effectively control "the personality" of the lighting.

Reflectors. Whenever shooting outdoors, it is a good idea to carry along a large portable reflector—the larger it is, the more effective it will be. Portable light discs, reflectors made of fabric mounted on a flexible and collapsible frame, come in a variety of diameters and are very effective. They are available from a number of manufacturers and come in silver (for maximum fill output), white, gold foil (for a warming fill light), and black (for subtractive effects). With foil-type reflectors used close to the subjects, you can sometimes even overpower the ambient light, creating a pleasing and flattering lighting pattern.

The fill reflector should be used close to the subject, just out of view of the camera lens. You will have to adjust it to create the right amount of fill-in, observing the lighting effects from the camera position. Be careful not to bounce light in from beneath the eye/nose axis; this is generally unflattering. Also, try to "focus" your reflectors (this really requires an assistant), so that you are only filling the shadows that need filling in. It helps to have an assistant or several light stands with clamps so that you can precisely set the reflectors.

Fill Flash. More reliable than reflectors for fill-in is electronic flash. For this purpose, many portrait photographers prefer barebulb flash, a portable flash unit with a vertically positioned flash tube. This flash fires a full 360 degrees, so you can use wide-angle lenses without worrying about light falloff. Barebulb flash produces a sharp, sparkly light, which is too harsh for almost every type of photography *except* outdoor work. The trick is not to overpower the daylight. You can also enhance the flash by placing a warming gel over the clear shield used to protect the flash tube and absorb UV. This will warm the facial lighting but not the rest of the scene. It's a beautiful effect.

Other photographers like softened fill-flash. Robert Love, for example, uses a Lumedyne strobe inside a 24-inch softbox. The strobe is triggered cordlessly with a radio remote. He uses his flash at a 45-degree angle to his subject for a modeled fill-in, not unlike the effect you'd get in the studio.

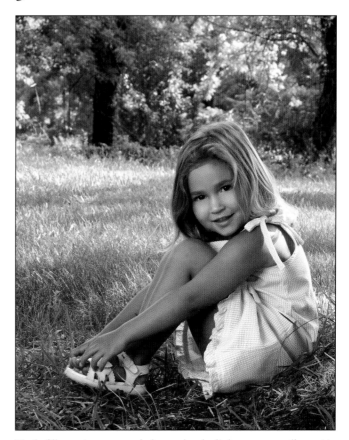

Flash-fill requires you to balance the daylight exposure (here, $\frac{1}{15}$ second at f/11 at ISO 400) with the flash output. The result is an evenly balanced background and a well lit subject. Here, the light source was backlight from direct sunlight and the flash was a diffused, off-camera flash set to fire at an output of around f/8—slightly less than the ambient light reading. Photograph by David Bentley.

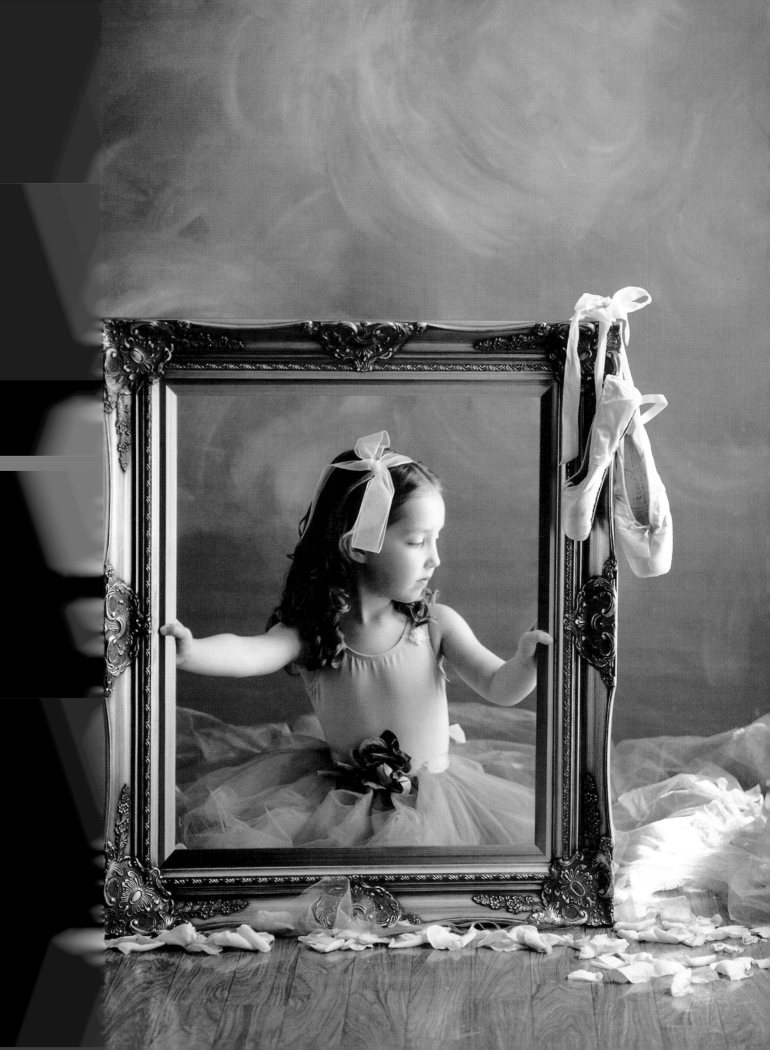

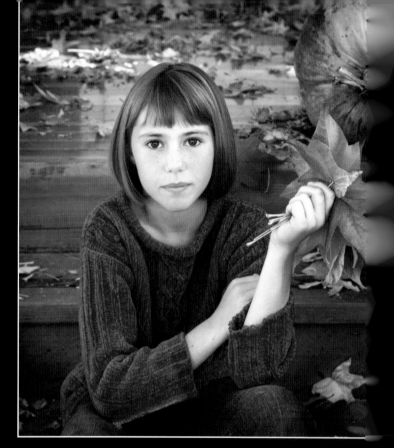

FACING PAGE—Elizabeth Homan's studio features diffused daylight from a large picture window. Elizabeth created a portrait of the tiny dancer within the portrait by having the girl hold the frame, thus creating a unique composition within the composition. No fill-in was used in order to produce a dramatic fall off of light on the shadow side.

RIGHT—In this image, most of the lighting refinements and intense coloration were done in Photoshop by the photographer, Kersti Malvre. The result appears natural, as if this were a found scene with lovely lighting, which was not the case.

BELOW—Fran Reisner's studio is built around harnessing available light. Large windows and glass double doors admit lots of light and, because it all comes from one direction, she uses large white unlit softboxes as reflectors. Sometimes she will power the softboxes down and use them for a barely noticeable fill, but most often she uses them with the lights extinguished as mobile fill cards.

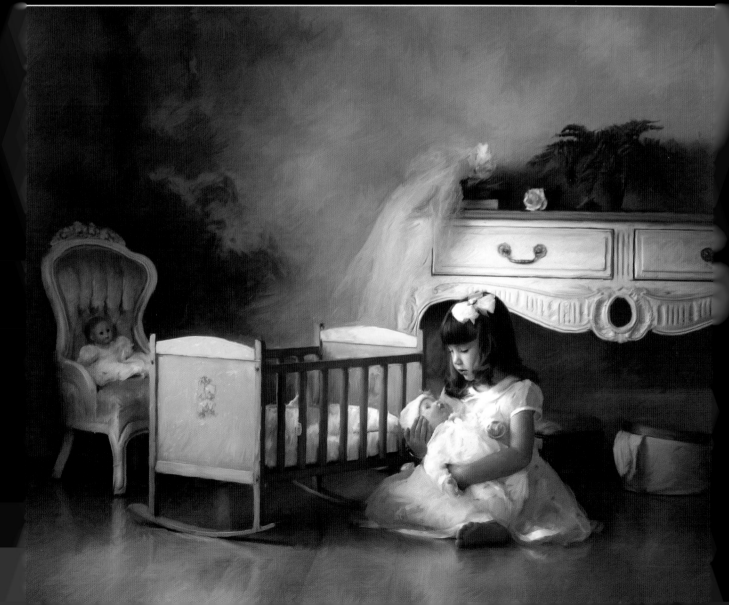

Soft, directional window light is ideal for kids' portraits. Here, Janet Baker Richardson had her subject lean into the light and look back to the camera, allowing the soft light to wrap around the subject's face. Janet made sure to employ a secondary light source in the background (a room light) to open up dark areas and provide good tonal separation.

Another popular flash-fill system is on-camera TTL flash. Many on-camera TTL flash systems offer a mode that will balance the flash output to the ambient-light exposure. These systems are variable, allowing you to dial in full- or fractional-stop output adjustments for the desired ratio of ambient-to-fill illumination. They are marvelous systems and, more importantly, they are reliable and predictable. Some of these systems also allow you to use the flash off the camera with a TTL remote cord.

To determine your exposure with non-TTL flash fill, begin by metering the scene. It is best to use a handheld incident flashmeter in ambient mode, then point the hemisphere at the camera from the subject position. Let's say the metered exposure for the daylight is $\frac{1}{15}$ second at f/8. Now, with the meter in flash-only mode, meter just

the flash. Your goal is for the output to be one stop less than the ambient exposure. Adjust flash output or flash distance until your flash reading is f/5.6. Then, set the camera and lens to $\frac{1}{15}$ second at f/8.

When using fill flash, remember that you are balancing two light sources in one scene. The ambient light exposure will dictate the exposure on the background and the subject. The flash exposure only affects the subject.

TWILIGHT

The best time of day for making great portraits is just after the sun has set. The sky becomes a huge softbox and the effect of the lighting on your subjects is soft and even, with no harsh shadows. Because the setting sun illuminates the sky at a low angle, you have none of the problems of overhead light.

There are two problems, however, with working at twilight. One is that it's dim, so you will need to use medium to fast ISO speeds combined with slow shutter speeds. This can be problematic with children. Working in subdued light also forces you to use wide lens apertures, restricting the depth of field.

Another problem in working with twilight is that it does not produce catchlights in the eyes of the subjects. For this reason, most photographers augment the twilight with some type of flash, either barebulb flash or softbox-mounted flash, which provides a twinkle in the eye and freezes subject movement.

If the sky is brilliant in the scene and you want to shoot for optimal color saturation, you can use the flash to overpower the daylight exposure by up to one stop. This makes the flash the main light and the lets the soft twilight function as the fill light. The only problem with this is that you will get a separate set of shadows from the flash. This can be fine, however, since there aren't really any shadows from the twilight—but it is one of the side effects.

WINDOW LIGHT

One of the most beautiful types of lighting for children's portraits is window lighting. It is a soft, wraparound light that minimizes facial imperfections. Yet, it is also a highly directional light, yielding excellent modeling with low to moderate contrast. Window light is usually fairly bright and it is infinitely variable. It changes almost by the minute, allowing you to depict a great variety of moods,

depending on how far you position your subjects from the light.

Many children's photographers use a window seat in their studios. The windows, which wrap around the alcove of the window seat, produce a broad expanse of diffused daylight that is perfect for children's portraits.

Window Size. The larger the window or series of windows, the more the soft, delicate light envelops the subject. Window light seems to make eyes sparkle exceptionally brightly, perhaps because of the size of the light source relative to the subject.

Falloff. Since daylight falls off rapidly once it enters a window—it is much weaker just a few feet from the window—great care must be taken in determining exposure.

You will need reflectors to kick light into the shadow side of the face. Have an assistant do this for you so you can observe the effects at the camera position.

Time of Day. The best quality window light is the soft light of mid-morning or mid-afternoon. Direct sunlight is difficult to work with because of its intensity and because it often creates shadows of the individual windowpanes on the subject.

Backlighting. Window light can also be used as a backlight with silver or gold reflectors employed to fill in the frontal planes of the face. This is a very popular strategy for children's portrait lighting—especially with translucent curtains hung in the windows for some diffusion. With this type of lighting, it is important to expose

Window light can be a beautiful and pleasing light. A simple foil reflector is all that is needed to open up the shadows created by the window light, which is acting like a main light. Anthony Cava created this wonderful portrait of a flower girl taking a little shoe break.

LEFT—Fernando Basurto captured this priceless window-lit portrait of young Rufus at one of his weddings. You can see the square catchlights of the window in the subject's eyes. Even though Fernando moved the child back from the window, which makes the light less diffuse, the lighting effect is still pleasing. In the printing of this image, the left side of Rufus's face was slightly darkened, as was his ear on that side, which was getting too much direct light from the window. This provided good evenness, allowing you to focus on his eyes, which are the centerpiece of this portrait.

FACING PAGE—Sometimes Fran Reisner will use only the forward-most bank of windows in her available light studio. Here she used the closest window and no fill to create a little stronger lighting ratio than she normally uses. Note the other portrait from this set in this chapter—she simply moves in new furniture and props and has an entirely new set to work with her child subjects.

Light diffused in this manner has the warm feeling of sunlight but without the harsh shadows. Since this diffused light is so scattered, you may not need a fill source—unless working with a group of children. In that case, use reflectors to kick light back into the faces of those farthest from the window.

Fill Light. You can set up a white or silver card opposite the window and, depending on the distance to the window, the reflector may provide enough illumination on its own for adequate fill. If not, consider using bounce flash. While bounce flash may not be great as a primary light source for making children's portraits, it is an ideal light source to supplement primary light sources, such as window light.

TTL flash metering systems read bounce flash very accurately, but factors such as ceiling distance, color and absorption qualities can affect exposure. Although no exposure compensation is needed with these systems, operating distances will be reduced in bounce mode. Most camera-mounted flash units will also swivel so that you can bounce the flash off a side wall or even a reflector. These are ideal, since they will balance with your ambient light to provide the desired amount of fill-in.

In practice, meter the window light first and then set the bounce flash to produce $\frac{1}{3}$ to 1 full f-stop less than the ambient-light reading. A test shot, verified on your camera's LCD screen, is the way to check that the bounce flash is effectively filling in the shadows.

for the face and not the background of illuminated curtains. In some cases, the difference in exposure can be up to three stops.

Diffusing Window Light. If you find a nice location for a portrait but the light coming through the windows is direct sunlight, you can diffuse the window light by taping some acetate diffusing material to the window frame. Some photographers carry translucent plastic shower curtains with them just for this purpose. If the light is still too harsh, try doubling the thickness of the diffusion material.

A tool made specifically for diffusing window light is a translucent lighting panel, such as the 6x8-foot one made by Westcott. It is collapsible for portability but becomes rigid when extended and can be leaned into a window sill to create beautifully diffused light.

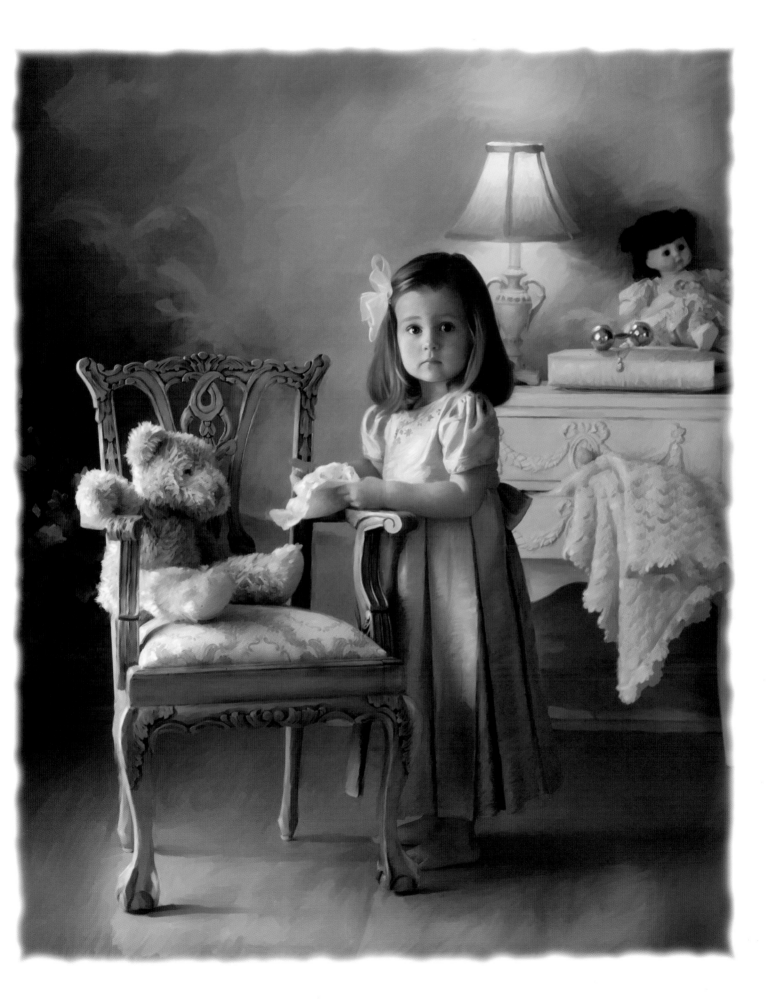

5. POSING

Although this is a book concerning fine portraiture, there is really no point in going into the various formal posing rules and procedures used for adults. They simply don't apply. Even if a two-year-old could achieve proper head-and-neck axis, for example, the likelihood of him or her holding the pose for more than a nanosecond is slim. Additionally, since little ones are mostly non-verbal, posing instructions are completely ineffective. So then, how does one pose children, especially small children?

THE BASICS
Facial Analysis. The minute any good photographer meets a client he begins to make mental notes as to which side of the face he wants to photograph, any irregularities (like one eye smaller than the other), facial shape (round, elliptical, elongated), color of the eyes, posture, and so on. The expert photographer will catalog these features and devise a strategy to light, pose, and photograph the child. Keep in mind that while most babies are blessed with flawless skin, their tresses may be a bit sparse at first. Also, depending on how the child was born (i.e., either natural childbirth or Caesarean), he may have an elliptically shaped head.

Use an Assistant. When photographing small children and babies, you really need to have an assistant. Whether the assistant is down at eye level with the child or behind the camera is strictly up to you—whatever works best. While one of you is distracting the child, the

FACING PAGE, TOP—The photographer must put newborns into an environment where they are supported. Here, David Bentley created a soft bed that confines the baby and yet is comfortable enough for her to sleep soundly. If you look carefully you can see the outlines of the baby bed under the many layers of blankets.

FACING PAGE, BOTTOM—Unlike newborns and toddlers, who are often photographed from above, photographing older kids requires that you use adult standards of camera height, in this case around chin height, to divide the portrait into equal halves (horizontally). This priceless portrait was created by Deborah Lynn Ferro.

LEFT—Studios that photograph lots of babies and toddlers have a variety of props, like this beautiful painted beach background and large oyster shell. What you don't see are the cloth diapers and other padding inserted in the shell to support baby, who appears to be feeling right at home. Photograph by Deborah Lynn Ferro.

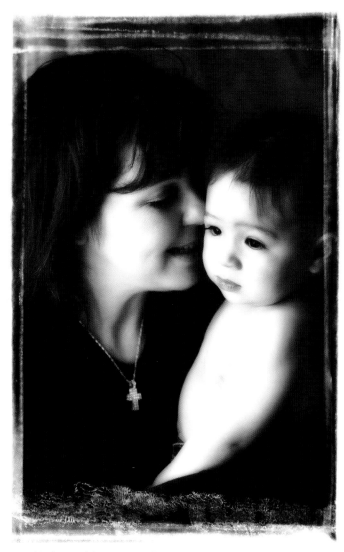

In this beautiful portrait of mother and child by Judy Host, a higher-than-normal camera position is used. Because the focal length is longer than normal (65mm), however, there is no subject distortion. The image was made with a Kodak DCS Pro 14n and given a border treatment like a Polaroid transfer print in Photoshop.

other can concentrate on the lighting, composition, and background.

Safety First. With small children or infants, safety is always the first consideration. A child who cannot sit up by himself cannot be propped up in a chair or left alone on posing blocks. Instead, the child should be positioned on the floor or ground, with pillows or other soft supports nearby. Usually, the parent should be close by and the child should never be left unattended.

Put Mom or Dad to Work. Infants will sometimes stay put, but other times they will crawl off and have to be brought back. Having a parent close at hand makes things much easier, giving the baby some reassurance in a strange environment. It also helps the photographer

evoke special emotions and expressions. The photographer can say to the child, "Look at Daddy, isn't he silly?" This is Dad's cue to act goofy or in some way amuse the child.

Do What Comes Naturally. It is important to let children do what comes naturally. Amuse them, be silly, offer them a toy or something that attracts their attention, but do so with a minimum of direction. Kids will become uncooperative if they feel they are being over-manipulated. Make a game out of it so that the child is as natural and comfortable as possible. Generate a smile, but don't ask them to smile. You will probably not get what you want.

Camera Height. Be aware of perspective and its positive and negative effects when posing children. For a head-and-shoulders portrait, the camera should be at the child's nose height—too high and you will narrow the child's cheeks and chin; too low and you will distort the shape of his/her head. For three-quarter length and full-length poses, the camera height (especially with shorter focal lengths) should be midway between the top and bottom of the areas of the child's body to be shown in the frame.

Keeping the camera at the same level as the baby also helps you relate to the child on his or her own level. Psychologically, this is important. Instead of leering over a small child with strange and unfamiliar equipment and funny-looking lights, you are putting yourself "on the same level" as the child.

Touching. Sometimes no matter how simply you explain what you want the child to do, he or she just won't understand your instructions. The best way to remedy the situation is to gently touch the child and move the errant curl or slide them over just a bit on the posing block—whatever it happens to be. Be advised that touch-

USE A CABLE RELEASE

Many expert children's portrait photographers work with a camera on a tripod and a long cable release. This frees them from the camera position, allowing better interaction with the child. In such situations the composition must be a bit loose, in case the child moves. Also, observe the child's movement when focusing, to get an idea of where your focus point should be and how far your depth of field extends within the scene. Take your best estimate on focus and ensure that you'll have enough depth of field, even if the child moves, to get a sharp image.

ing can be intimidating to children, particularly since you are a stranger. Always ask first and then be gentle and explain what you are doing. If the child is shy, have Mom or Dad move the child per your directions.

Work Quickly. With kids, especially small children, you don't have much time to work, so be sure your lights and background are roughly set before bringing the child into the studio or into the area where you're going to make the photograph. You have about thirty minutes in which to work before the child gets tired or bored or both. This is another reason to have an assistant who can

hand you a new memory card, adjust a light, or the fold of a blanket without you having to move from the camera position. Always be ready to make a picture; children's expressions are often fleeting. That said, you cannot rush a good portrait. Be prepared to spend some time laying the groundwork—gaining the child's trust and letting him acclimate to the strange surroundings.

THE FACE

Head Positions. There are three basic face positions in portraiture. They dictate how much of the face is seen by

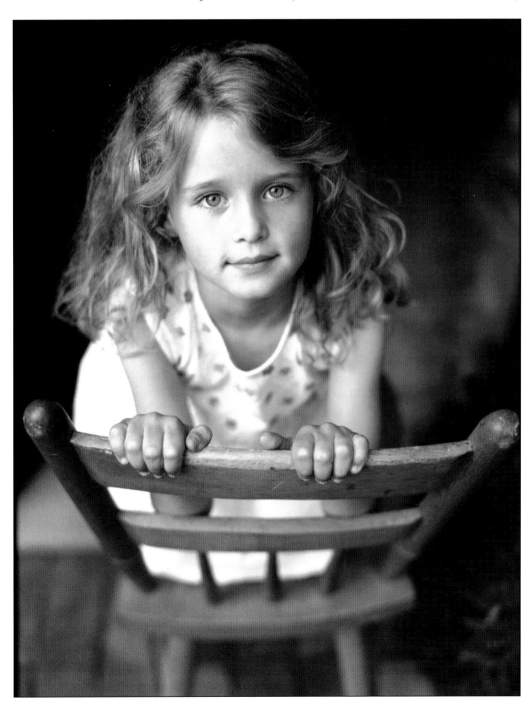

A child's eyes are full of honesty and genuine personality. Little kids are incapable of guile so what you see reflected in their eyes is true self. Janet Baker Richardson captured this beautiful girl in a pensive happy moment. Janet wanted only the face and hands sharp so she photographed the girl wide open with a relatively fast shutter speed by existing daylight.

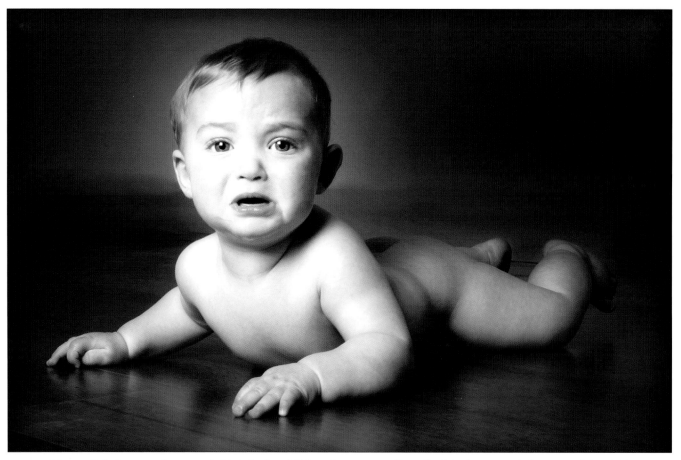

ABOVE—Marcus Bell chose to photograph this baby in a full-length pose, revealing all of the beauty and character of the child. Marcus photographed the child with a large softbox close to the floor, where the baby was posed. He wanted the entire child sharp, so he chose an angle that would capture the sharpness from his nose to his toes. In digital printing, Marcus darkened the legs and torso so that the face would be prominent, but left these areas open enough to see the beautiful detail throughout. This is a classic children's portrait.

FACING PAGE—Brian Shindle makes exquisite portraits of children, sparing no expense and not overlooking a single detail. The beaded dress is captured elegantly with dual softbox lighting. The little girl is almost head on to the camera, but her extended right arm gives a beautiful base to the composition as well as displaying the very expensive dress. Her expression is reflective, in the manner of classical portraits. The orange floral display adds a beautiful counterpoint to the rest of the warm-toned portrait.

the camera. With all three of these head poses, the shoulders should remain at an angle to the camera. These views are easily accomplished even with small children. Their attention can be diverted to get them to look in the direction that adds the right dynamics to the pose. Alternately, you can prearrange the posing furniture at the precise angle you want to the camera lens.

Seven-Eighths View. The seven-eighths view is when the subject is looking slightly away from the camera. From the camera position, you see slightly more of one side of the face than the other. You will still see the subject's far ear with this pose.

Three-Quarter View. With a three-quarter view, the far ear is hidden from the camera and more of one side of the face is visible. The far eye will appear smaller because it is naturally farther away from the camera than the near

eye. It is therefore important when posing the child in this view to position him or her so that their smallest eye (people usually have one eye that is slightly smaller than the other) is closest to the camera, thus making both eyes appear normal size.

Profile. In the profile, the head is turned almost 90 degrees to the camera. Only one eye is visible. In posing a child in profile, have your assistant direct the child's attention gradually away from camera position. When the eyelashes from the far eye disappear, your subject is in profile.

Tilting the Head. The tilt of the head is physically complex. There are only two ways to tilt the child's head: toward the near shoulder or toward the far shoulder. Which way depends on the composition and lighting. You can ask your assistant to tilt his or her head slightly

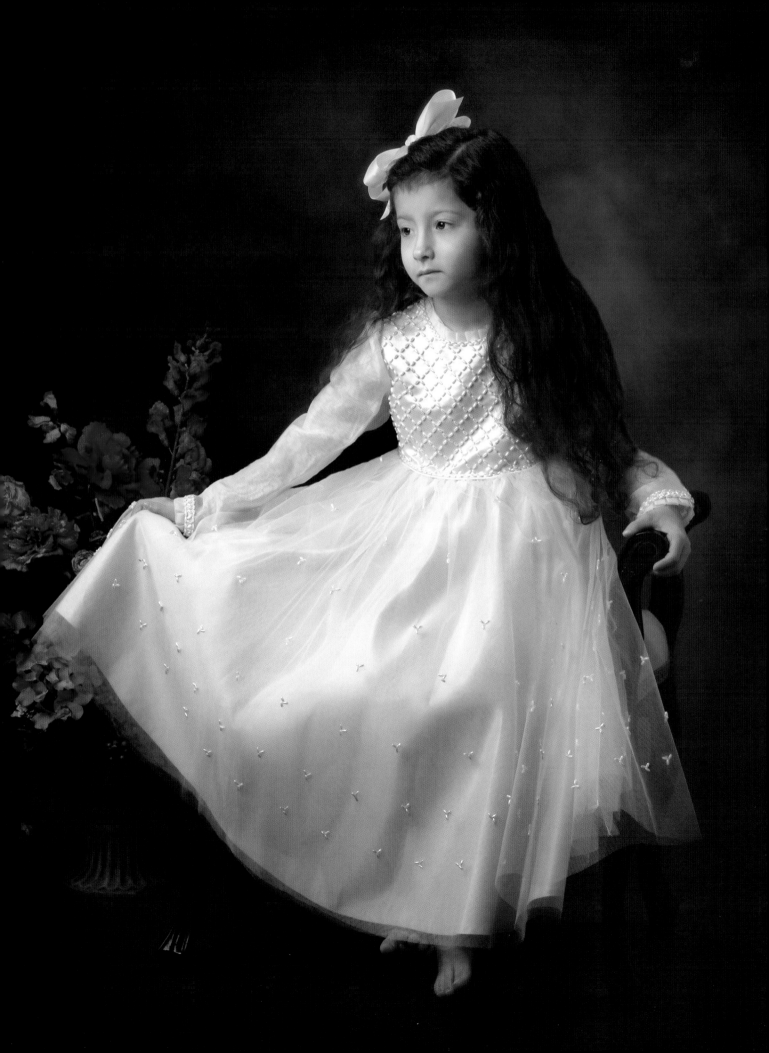

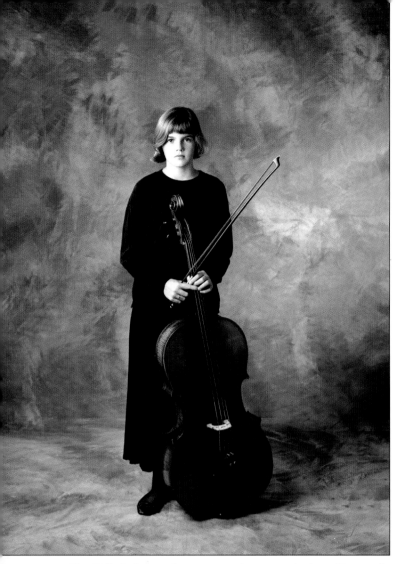

Tim Kelly believes a fine art portrait transcends time. "It goes far beyond the utilitarian uses of the subjects, the people portrayed," he says. In this wonderful portrait of a young cellist, Kelly reveals the shy intensity of the girl and a quiet intelligence. "Expressions" are external indicators of character and Tim is a master at revealing the personality and essence of his subjects.

and ask the child, "Can you do this?" but usually you will get an exaggerated version of the pose. Although difficult to achieve, this posing point introduces yet another dynamic line into the composition.

The Eyes. A child's eyes reflect all of the innocence and vulnerability that are the essence of childhood. For this reason, it is imperative that the eyes be a focal point of any children's portrait.

The best way to keep the child's eyes active and alive is to engage him or her in conversation or a game of some type. If the child does not look at you when you are talking, he or she is either uncomfortable or shy. In extreme cases you should let Mom do all of the enticing. Her voice is soothing to the child and will elicit a positive expression.

The direction in which the child is looking is important. Start the session by having the child look at you. Using a cable release with the camera tripod-mounted forces you to become the host and allows you to physically hold the child's gaze. The basic rule of thumb is that you want the eyes to follow the line of the nose. When your assistant holds an object for the child to see, have him or her move it back and forth, so that the eyes follow the object.

The colored part of the eye, the iris, should border the eyelids. In other words, there should not be a white space between the top or bottom of the iris and the eyelid. If there is a space, redirect the child's gaze.

Pupil size is also important. If working under bright modeling lights (strobes are recommended over incandescent lights because of the heat factor), the pupils will contract. A way to correct this is to lessen the intensity of the modeling lights. You can always increase the intensity to check the lighting pattern and quality. Just the opposite can happen if you are working in subdued light; the pupils will appear too large, giving the child a vacant look.

Expressions. Kids will usually mimic your mood. If you want a soft, sweet expression, get it by speaking in soft, quiet tones. If you want a big smile, bring the enthusiasm level up a few notches.

Above all, be enthusiastic about taking the portrait. The more they see how fun and important this is to you, the more seriously the child will take the challenge. After a few frames, tell them how great they look and let them know how things are going. Like all people, children love to be told they are doing a good job.

Never tell children to smile. Instead, ask them to repeat a funny word or ask them their favorite flavor of ice cream. And don't be afraid to create a more serious portrait—the best expressions aren't just the big smiles. A mix of portraits, a few with smiles and some showing the child's gentler side, is usually appealing to parents.

THE BODY
First and foremost, do not photograph a child (or adult) head-on with their shoulders square to the camera. This is the mug-shot type of pose and, while it is acceptable in close-up portraits, it is generally not recommended. The shoulders should be at an angle to the camera. This is easily accomplished by arranging any posing stools, chairs, or

blocks on an angle to the camera. Then, when the child is put into the scene, the shoulders are already turned. This technique introduces a visually pleasing diagonal line into the composition.

The Head-and-Shoulders Axis. Step two, which is often a function of luck with children, is to turn the head to a slightly different angle than the angle of the shoulders, thus introducing a second dynamic line into the composition. In traditional male portraiture, the head is more often turned the same direction as the shoulders; with women, the head is usually turned to an opposing angle. The only reason this is mentioned is so that you are aware of the difference.

You can often redirect the line of the child's head by having your assistant hold up something interesting within eyesight of the child, then move it in the direction that turns the child's head slightly. By turning the shoulders and face slightly away from the camera, you allow the frontal planes of the face to be better defined with light and shadow.

Arms and Hands. Regardless of how much of the child is visible in the viewfinder (i.e., whether it is a head-and-shoulders, three-quarter-, or full-length portrait), the arms should not slump to the child's sides. Often, giving the child something to hold will encourage them to raise their hands to more closely inspect the object. This creates a bend in the elbows and introduces more dynamic lines to the composition. Not only are a child's hands interesting, but having them visible means that the elbows are bent, thus providing a triangular base to the composition, which attracts the viewer's eye upward, toward the child's face.

Babies can sometimes just barely support their own weight. This image made by Kevin Jairaj, is a classic. The lighting is soft and delicate—a mixture of soft shade and more powerful reflected light from a handheld reflector to camera left. The expression is priceless—and, unlike adults, babies don't mind having arms like the Michelin man. Image made with a Sony Cybershot at $\frac{1}{400}$ second at f/2.4 at ISO 100 and at the 48mm focal length setting.

ABOVE—Moving in close can create an intimate pose—and Mom doesn't have to put Baby down in a strange studio environment. Judy Host made this delightful image with a Kodak DCS Pro 14n and a zoom lens set to the 65mm setting.

FACING PAGE—A newborn baby will be perfectly content when in its mother's arms. Frances Litman made this wonderful portrait with a Nikon D70 and 80–200mm f/2.8D ED AF Zoom-Nikkor lens set to the 90mm setting.

A child's hands are delicate and beautiful and should be included whenever possible. While it is basically impossible to pose children's hands—other than by giving them something to hold—you can gain some control by varying the subject distance and focal length. If using a short focal length lens, for example, hands will be close to the camera and appear larger than normal. Using a slightly longer-than-normal focal length sacrifices the intimacy of working close to the child, but corrects the perspective and controls this situation. Although holding the focus of both hands and face is more difficult with a longer lens, the size relationship between them will appear more natural. And if the hands are slightly out of focus, it is not as crucial as when the eyes or face are soft.

While the vast majority of hand poses are not particularly useful to this discussion, it should be noted that the most flattering results are obtained when the edge of the hand is photographed, as hands pointing straight into the lens appear "stumpy." Also, where possible, fingers should be photographed with slight separation. While it is impractical to do much about hands with children, it is useful information to know.

THREE-QUARTER- AND FULL-LENGTH POSES

Where children are concerned, the difference between three-quarter length and full-length poses is slight. There are a few things you should keep in mind, however.

A three-quarter-length portrait is one that shows the subject from the head down to a region below the waist. This type of portrait is best composed by having the bottom of the picture be mid-thigh or below the knee and above the ankles. You should never "break" the composition at a joint—at the ankles, knees, or elbows. It is visually disquieting.

A full-length portrait shows the subject from head to toe. This type of portrait can be made standing or sitting, but it is important to remember to angle the child to the lens or adjust your camera position so that you are photographing the child from a slight angle. The feet, ordinarily, should not be pointing into the lens.

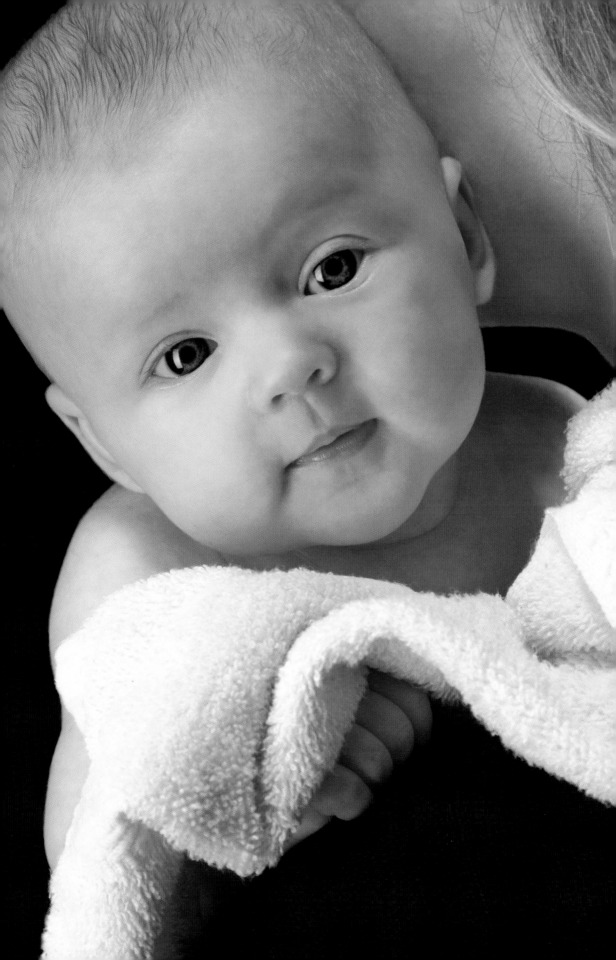

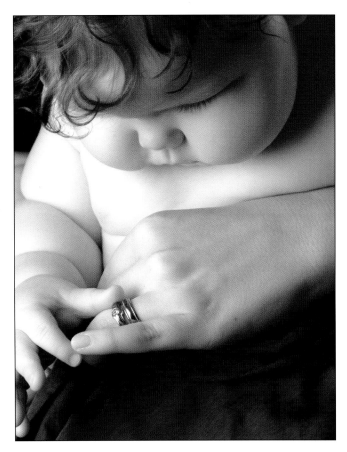

LEFT—Pictured in Mom's lap, this big boy is completely fascinated by Mom's gold rings. Working in close and eliminating all but the fundamental parts of the image strengthens the photograph. Image made with Nikon D70S and 70–300mm f/4-5.6D ED AF Zoom-Nikkor at the 300mm setting. Photograph by Frances Litman.

FACING PAGE—Small babies, particularly after a feeding, need a nap, which is a perfect time to make a sleeping shot. Here the sleeping baby is held carefully and securely in a chiffon net. The photographer, Jeff Hawkins, was able to take his time and produce an elegant lighting effect on the baby and the fabric.

hand the child over. For example, you can have Mom lie down on the floor with the baby next to her. There is no feeling of detachment since Mom is nearby (just position the mother slightly out of frame). If she is like most moms, she can rest the baby on her hip and lean away, giving you a clear vantage point for a head-and-shoulders portrait of the baby, who will be very happy to be with his or her mother. There are many variations of this pose and, since the baby will move wherever you tell the mother to move, you can pose the child with precision. Try to include the baby's hands in the photo, which can be easily done by giving the child something interesting to hold on to. Hands more completely define a baby portrait.

Babies produce an extraordinary range of expressions. Sometimes, by zooming in with an 80–200mm zoom lens, for example, you can fill the frame with the baby's face. If he or she is not being too wiggly, you can elicit a dozen completely different facial expressions. A series like this makes a beautiful sequence or montage. Be careful not to loom over the baby with too short a focal-length lens, or you will look like a Cyclops to him!

Two-Year-Olds. When two-year-olds are involved, even the best laid plans rarely work out. You have to be flexible and open.

Don't compose an overly tight set in which to photograph the child. Two-year-olds will do whatever they want. They are experiencing mobility (walking around) and the beginnings of speech (getting what they want by asking for it), and this leads to an independence that causes them to be known as "terrible twos." A loosely structured set in which they have some mobility (or better yet, an outdoor scene where they have a lot of mobility) is recommended. You can, of course, with good communication and patience, direct the headstrong two-year-old—but not for long.

When working with two-year-olds, it is best to hand-hold the camera and follow them as they move around.

When the child is standing, hands become a real problem. If you are photographing a boy, have him stuff his hands in his pockets—it's an endearing pose. You can also have him fold his arms, although children sometimes adopt a defiant stance in this pose. With a little girl, have her put one hand on her hip, making sure you can see her fingers. Full-size chairs make ideal props for standing children because the child's hands can easily be posed on the arm of the chair or along the chair back.

When a little child is sitting, have them curl one leg under the other. This makes them into a human tripod—very stable and upright. Children are comfortable in this pose and have the full use of both hands so that they can hold or play with any toy or a prop you may have given them. Best of all, they usually don't wander off from this pose, unless they're very active.

POSING TIPS BY AGE

Babies. Babies, particularly at early stages in their development, are inseparable from their mothers. What happens when you want to "remove" baby from Mom to make the portrait? Baby will not normally react well. To avoid this situation, you can make some beautiful close-up portraits of the baby without Mom ever having to

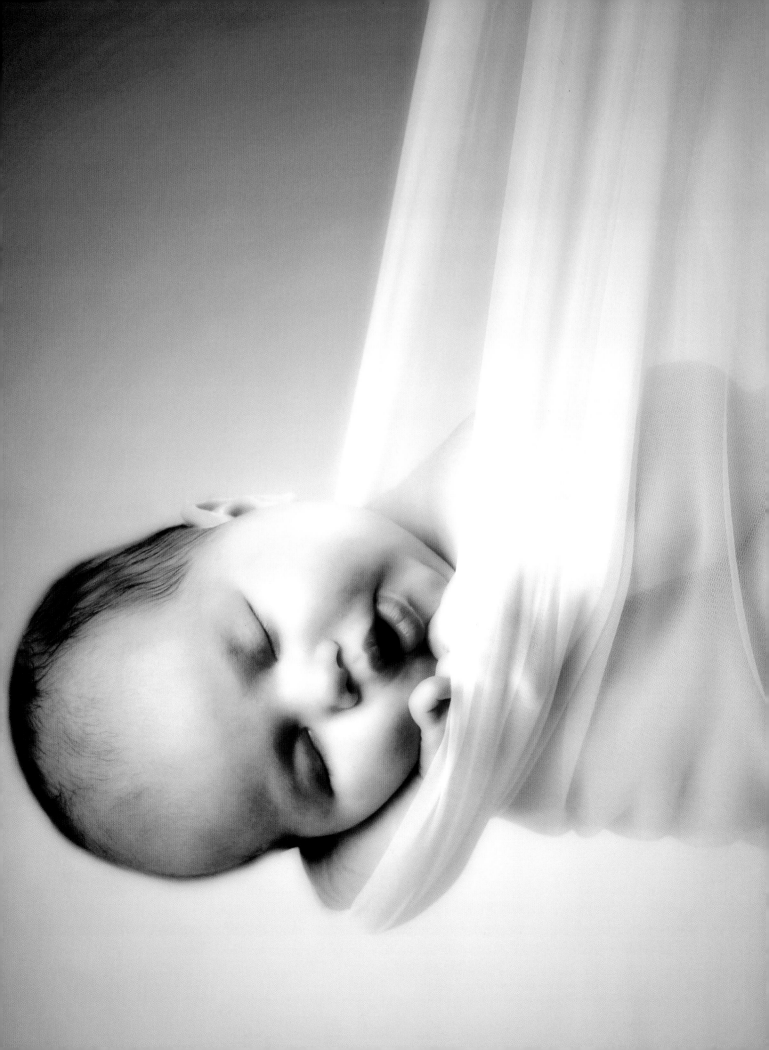

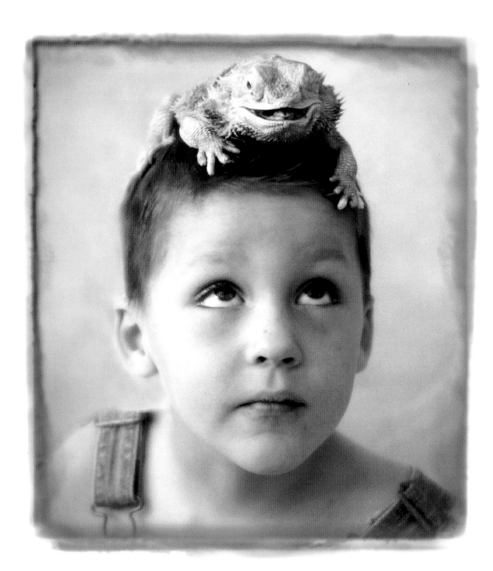

When you are photographing a child and his pet, very little needs to be done to elicit priceless expressions. Photograph by Kersti Malvre. The image was softened and given a unique edge treatment in Photoshop.

This will often require shooting a lot of frames and it may inhibit your lighting setup. Available light is often best with these active subjects.

Older Children. With older children the best way to elicit a natural pose is simply to talk to them. Kids are totally uninhibited and will talk to you about anything under the sun. Good topics involve your surroundings, if you are working outdoors, for example. Or you can talk about them—their interests, brothers and sisters, pets, and so on. While it is not necessary to talk all the time, be aware that silence can be a mood killer and may lead to self-consciousness. Try to pace the conversation so that you are both engaging and yet free to set up the technical details of the photo.

Kids also like being treated like as equals. They don't like being talked down to and they value the truth. Be honest about what you expect of the child and get them involved in the process of making the picture. You can even try asking them how they would like to be photographed—kids like to be asked their opinion and they might just come up with a great idea.

With children, it is a good idea to size up personalities—just as you would with an adult. A good plan is to ask children about their favorite thing to do, then watch how they react when they start to think about it. If a child is on the quiet side, any kind of wild, exaggerated behavior might send him screaming. In this case, try a quiet story and some low-key talking. With very shy children, you may even have to stay in the background and let the parent direct their child, following your instructions. In these situations, you might want to use a longer lens and back off so that you are not part of the interaction.

Well-known portrait photographer Frank Frost thinks that kids are too sharp to have anything pulled over on them. Before he starts a photo session, Frost gets down on the floor and visits with the child. He always uses an assistant, noting that he doesn't see how it's possible to get great expressions from children and babies *and* han-

dle all of the technical details and posing. His assistant hams it up with the child while Frost readies the lights and camera. To make his studio a place children want to return to, he keeps a small toy box in the studio, which children always seem to remember fondly.

POSING AIDS

Posing Steps. Many children's photographers maintain several sets of portable posing steps or blocks that can be used individually or in tandem for several children. These items are usually made of wood and can be draped with fabric, such as crushable backgrounds. Steps or blocks provide good support and are safe for toddlers to crawl on up. They will also work well for photographing more than one child at a time because they instantly get the faces on different levels—a must for good composition.

You can drape and position these items before the child arrives so that once the lighting is set you can bring the child over and he or she will sit naturally and fall into a normal, believable pose. A great advantage to using posing blocks in the studio is that they are large enough to conceal a background light placed behind them.

Chairs. Small children may often do better when "contained." For this reason, little chairs make great posing devices. Place a tiny pillow in the chair and then have Mom place the child in the chair. When all is set, cue Mom to call the child by name.

Adult-size chairs are also effective posing tools. The chair should be stable and visually interesting. A great pose is to have a child standing in the chair, holding onto the chair back and looking back over a shoulder at the camera. Have a parent or assistant nearby in case the child gets too adventurous. Antique stuffed or velvet chairs work beautifully for this kind of photo.

ACTIVITY-CENTERED POSES

Where little ones are concerned, posing really means maneuvering the child into a position in which he or she ap-

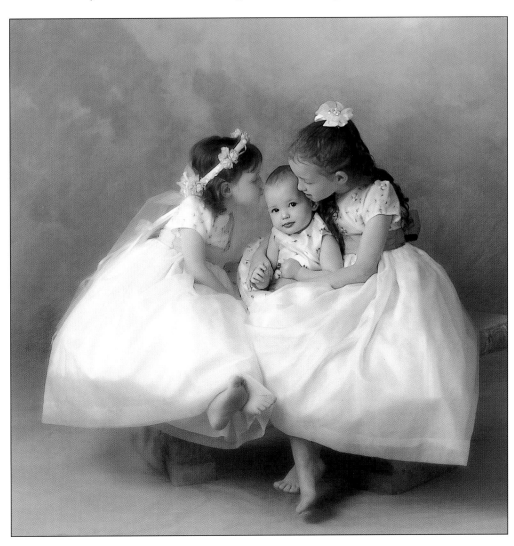

Tim Kelly is a master portrait artist whose specialty is understatement. He uses simple, almost nondescript painted backgrounds with understated posing furniture, which is used only to support and display the client, not to distract the viewer's eye from the subject. And about the subject's clothing, he says "I always subjugate the clothing."

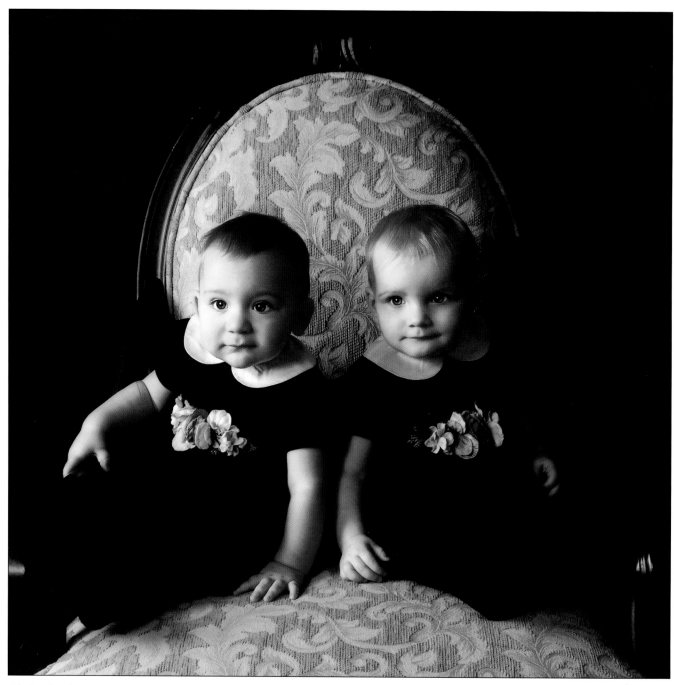

Obviously, these two sisters are too small to use the chair as adults would for posing, so the photographer posed them shoulder to shoulder and turned them away from each other, using the chair as a background. The result is effective and charming. Photograph by Deborah Ferro.

pears normal and natural. Little children react most positively to the concept of "activity-centered" portraits. In a typical shooting session, the assistant gets down on the ground with the child, just out of view of the camera. A full complement of props is on hand, including a bubble bottle and wand, a long wispy feather, a squeaker, and a storybook or two. When the photographer decides the lighting and other technical details are right, the assistant will begin to coax and entertain the child. A long feather

is a big hit and a great icebreaker. The feather provides both visual and tactile stimulation. Most children are fascinated and their expressions might range from curiosity to glee.

PROPS AND GAMES

Most children's photographers have a collection of props and toys for kids to play with. Mothers will probably bring a few of the child's favorite things too—a stuffed

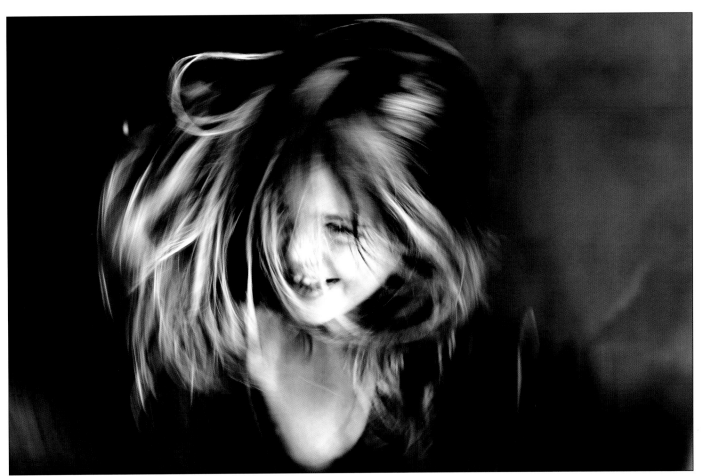

ABOVE—Spinning in circles is definitely a fun game, no matter how old the child. This wonderful portrait of Vanessa by Patti Andre captures the sheer joy of the activity. Patti used a moderately slow shutter speed of ¹⁄₆₀ second and a moderate ISO of 200 in order to capture some blur in the image.

RIGHT—Patti Andre, who specializes in custom storybook albums of kids, is also great at activity-based poses. This image is called *Kiss Poster*. The image was photographed in RAW mode and the white balance adjusted to a very warm tint in RAW file processing. The exposure was also adjusted in RAW mode to create a high-key effect. Image made with Canon EOS 1DS and 85mm f/1.2 lens.

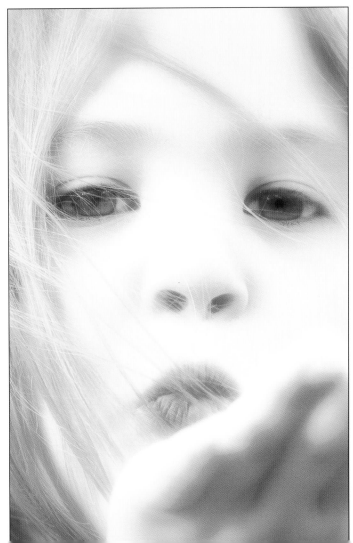

animal or a rattle or some other prized possession—and these can be used to attract and distract. Encourage parents to bring along items that will make the child feel comfortable and at home. This is usually not a problem with small children as they tend to travel with their favorite blanket or stuffed animal. Often, a few flowers make wonderful props, since small children are always fascinated by the color and shapes of flowers and enjoy holding something. Flowers can also add a little color and spice to your composition.

Usually it takes more than a prop to engage a child for the length of the photo session. Playing "make believe"

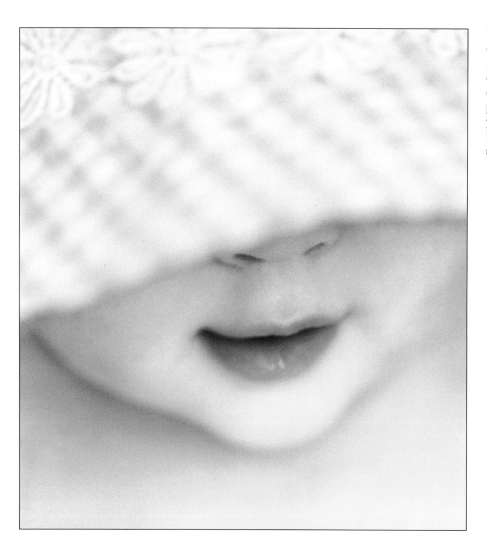

Isolating details, either zooming in or cropping in tighter on an image eliminates unwanted and often unnecessary details in the image. In this lovely image, children's portrait artist Suzette Nesire produced a very large head size of this youngster and by eliminating everything but the hat and part of the baby's face, she created a truly excellent image.

is a good option. Kids have a natural inquisitiveness that is easily tapped. Just start a sentence, "Imagine you're a . . ." Fill in the blank and you'll immediately see their imagination kick in!

Sometimes you just need to be silly with kids. Talk about your pet rhinoceros, or your other car, which is pink and yellow with purple seats. One photographer I know likes to ask kids, "Are you married?" which always gets a good chuckle. Peek-a-boo is another favorite—hide behind the camera and peek out from either side—the child will burst into laughter!

Overstimulation. All children need some stimulation to get good expressions, but a good assistant knows how to avoid overstimulating the child. Where this line in the sand falls depends on the age of the child. Because their attention span is so short, younger children need quite lot of stimulation—talking, imagining, being silly, making noise, etc. The same level of stimulation that keeps a one-year-old happy, however, will overstimulate an older child. This may end the session prematurely.

The Bribe. When it's getting toward the end of the session, many photographers use a bribe to keep the child interested for just a few more shots. Others use a reward system, giving the child a coloring book or other small gift for being such a good subject. One well known children's photographer offers cookies midway through a session as a means of keeping a little one's interest. (*Note:* It is important to get permission from a parent before doling out food!)

6. COMPOSITION

Composition in portraiture is no more than good subject placement within the frame. There are several schools of thought on proper subject placement, and no one school is the only answer.

THE RULE OF THIRDS

One of the basics in image composition is the Rule of Thirds. According to this rule, the rectangular viewing area is cut into nine separate squares by four lines (like a tic-tac-toe grid). In this grid, where any two lines intersect is an area of dynamic visual interest. These are ideal spots to position the main subjects in the group.

The subject of the composition does not necessarily have to be placed at an intersection of two lines; he or she could also be placed anywhere along one of the dividing lines. In head-and-shoulders portraits the eyes are the region of central interest, so it is a good idea if the eyes are placed on a dividing line or at the intersection of two lines. In a three-quarter or full-length portrait, the face is

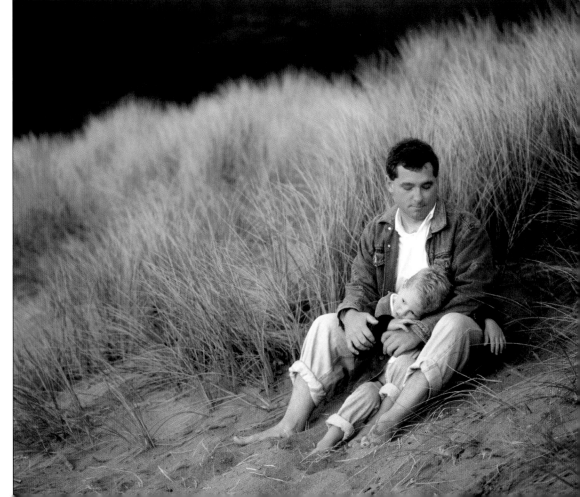

There are beautiful design elements at work in this portrait by Fran Reisner. First, the father and child are at a perfect intersecting point according to the Rule of Thirds. Second, the pose creates a strong diagonal through the image. Third, the position of the pair gives the portrait direction. The soft, warm light of twilight creates an emotional feel, and the father's large hands, which engulf the small child, make it clear that he has created a safe, wonderful place for the child.

ABOVE—In this pleasing portrait by Stacy Bratton, the baby is well centered, but the center of interest—her face—is past the center line of the image, implying movement and direction.

LEFT—This is a formal children's portrait by Drake Busath. The child's seated form mimics the classic L-shaped composition, and the line of the portrait, starting with the floral urn in the upper left corner and ending at the lower right corner, is an elegant diagonal, with several contrasting diagonal lines visible in the upper right hand corner. Note that the simple posing of the hands is adequate but not overdone and the young girl's expression is subtle, denoting a complexity warranted by such a formal composition.

the center of interest—thus, the face should be positioned to fall on an intersection or on a dividing line.

Usually the head or eyes are two-thirds from the bottom of a vertical photograph. Even in a horizontal composition, the eyes or face are usually at the top one-third of the frame—unless the subject is seated or reclining. In that case, they would generally be at the bottom one-third line.

Some DSLRs feature an in-viewfinder grid of the rule of thirds that can be activated at any time. I own two

Nikon DSLRs and keep the grid activated at all times because it helps as a reminder to choose a dynamic subject placement. This keeps your compositions from being center-weighted.

DIRECTION

Regardless of which direction the child is facing in the photograph, there should be slightly more room in front of the child than behind him. For instance, if the child is looking to the right as you look at the scene through the viewfinder, then there should be more space to the right side than to the left of the child in the frame. This gives a visual sense of direction.

Even if the composition is such that you want to position the child very close to the center of the frame, there should still be slightly more space on the side toward which he or she is turned. When the subject is looking directly at the camera, he or she should still not be centered in the frame. There should be slightly more room on one side or the other to provide visual direction.

PLEASING COMPOSITIONAL FORMS

Shapes in compositions provide visual motion. The viewer's eyes follows the curves and angles as they travel logically through the shape and, consequently, through the photograph. Subject shapes can be contrasted or modified with additional shapes found either in the background or foreground of the image.

The S-shaped composition is perhaps the most pleasing of all. The center of interest will usually fall on a one-third line, but the remainder of the composition forms a gently sloping S shape that leads the viewer's eye to the area of main interest.

Another pleasing type of compositional form is the L shape or the inverted L shape. This type of composition is ideal for reclining or seated subjects. The C and Z shapes are also seen in all types of portraiture and are both visually pleasing.

The pyramid is one of the most basic shapes in all art and is dynamic because of its use of diagonals with a strong horizontal base. The straight road receding into the distance is a good example of a found pyramid shape.

LINES

To master the fundamentals of composition, the photographer must be able to recognize real and implied lines within the photograph. A real line is one that is obvious—a horizon, for example. An implied line is one that is not as obvious—the curve of the wrist or the bend of an arm, for instance.

Real lines should not intersect the photograph at the halfway point. This actually splits the composition in two. It is better to locate real lines (either vertical or horizontal) at a point that is one-third into the photograph, thus providing visual "weight" to the image.

Implied lines should not contradict the direction or emphasis of the composition but should modify it. These lines should feature gentle, not dramatic changes in direction. Again, they should lead to the main point of interest—either the eyes or the face.

Lines, real or implied, that meet the edge of the photograph should lead the eye into the scene and not out of it. They should also pull the viewer's eyes in toward the center of interest.

TENSION AND BALANCE

Once you begin to recognize real and implied lines in your scenes and subjects and to incorporate shapes and curves into your portraits, you need to start employing tension and balance. Tension is a state of imbalance in an image—a big sky and a small subject, for example. Ten-

This trio of siblings forms a pleasing triangle shape, one of the most unifying of all shapes in art or photography. Also, notice the diagonal lines formed by the children's eyes—another means of introducing visual interest into a portrait. Photograph by Stacy Bratton.

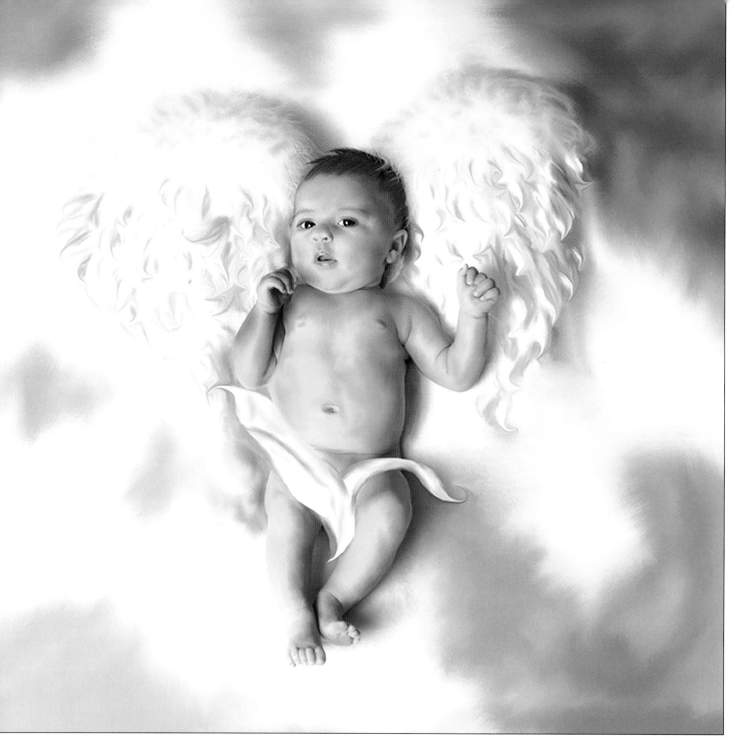

Sometimes an image can have overpowering symmetry and still create visual tension. In this painterly image by Deborah Lynn Ferro, the winged baby is centered in the square composition, left to right and top to bottom. Providing the needed visual contrast is the swirling lavender background, added to create a different visual weight in each of the four corners.

sion can be referred to as visual contrast. Balance is where two items, which may be dissimilar in shape, create a harmony in the photograph because they are of more-or-less equal visual strength.

Although tension does not have to be "resolved," it works together with the concept of balance so that, in any given image, there are elements that produce visual tension and elements that produce visual balance.

For example, a group of four children on one side of an image and a pony on the other side of the image produce visual tension. They contrast each other because they are different sizes and not at all similar in shape. But the photograph may be in a state of perfect visual balance by virtue of what falls between these two groups or for some other reason. For instance, using the same example, these two different subjects could be resolved visually if

the larger group, the children, is wearing bright clothes and the pony is dark colored. The eye then sees the two units as equal—one demanding attention by virtue of size, the other gaining attention by virtue of brightness.

SUBJECT TONE

The eye is always drawn to the lightest part of a photograph. The rule of thumb is that light tones advance visually, while dark tones retreat. Therefore, elements in the picture that are lighter in tone than the subject will be distracting. Bright areas, particularly at the edges of the photograph, should be darkened—in printing, in the computer, or in the camera (by masking or vignetting)—so that the viewer's eye is not distracted from the subject.

There are portraits where the subject is the darkest part of the scene, such as in a high-key portrait with a white background. This is the same principle at work as above; the eye will travel to the region of greatest contrast in a field of white or on a light-colored background.

FOCUS

Whether an area is in focus or out of focus has a lot to do with the amount of visual emphasis it will receive. A background that is lighter than the subject but distinctly out of focus will not necessarily detract from the main subject. It may, in fact, enhance the image, keeping the viewer's eye centered on the subject.

The same is true of foreground areas. Although it is a good idea to make them darker than your subject, sometimes you can't. If the foreground is out of focus, however, it will detract less from the subject, which, hopefully, is sharp.

A technique that is becoming popular is to diffuse an area of the photograph you want to minimize. This is usually done in Photoshop by creating a feathered selection of the area. Using this technique, the diffusion effect diminishes the closer you get to the edge of the selection.

At least two highly effective techniques are at work in this portrait by Drake Busath. The tone of the portrait is decidedly high-key, but the subject dominates because of the dark tone of her hat and coat. Also, the young girl is positioned between two stately trees, creating visual brackets on either side of her. The effect is to rivet your visual attention on the subject—your eye never wanders.

7. STACY BRATTON'S INSIGHTS

Technical skills are certainly required to be a top photographer in any field, but in the unusual world of children's portraiture, a savvy sense of developmental psychology is required to outsmart the subject. Not even actors or professional models, with their abun-

dant egos, rival the difficulty of small children. Small children are by far the most difficult subjects to photograph and your level of success depends on how much energy and expertise you bring to the session.

Having shot more that 2500 baby portraits over the years, photographer Stacy Bratton, has acquired volumes of information on sensory input and integration, a keystone of understanding child development and, consequently, the key to successfully photographing children. Her insights are unique and, to my knowledge, have never been included in any photography book before now.

SENSORY INPUT AND CHILDREN'S PORTRAITURE

According to Stacy, the majority of the population processes and integrates sensory stimulation unconsciously. Sensory input comes at all of us through a complex system of receptors: vision, hearing, smell, touch, taste, and a kinesthetic sense (an awareness and response to movement or physical activity). Other senses involved are coordination and equilibrium, which provide information about a body's position in space.

It is believed that sensory awareness is one of the first areas to fully develop in an infant's brain. As adults, we rarely think of how important our five senses are in terms of providing us with information about our world. We take for granted what it feels like to have wind blowing through your hair. Adults have forgotten the amazing visual delight of bubbles dancing across a room, nor do we remember the feel of popping that bubble and getting our hands sticky. Our sensory experiences have been bombarded for years upon years, so it is no wonder we do not appreciate the magic of simple stimuli around us. In fact, as we grow and mature both physically and mentally, we must learn to filter out most of the incoming stimuli

A GUARANTEE

Stacy guarantees her photo sessions. If the parents do not like the photos for any reason—including disliking something they themselves choose, such as clothing, Stacy and company will reshoot for free. This seems to help many families feel at ease. Stacy suggests being very honest about any problems you perceive before spending too much time on a session. She says, "If Mom really likes a certain outfit and you know it will not photograph well, tell her!" She also suggests showing her a test image before committing to a mistake in the finished images. Stacy continues, "I have had moms come in—many times actually—and complain about the child's haircut they just had this past week. If she does not like the haircut, she will not like the photos. It's as simple as that; you need to reschedule."

so we can focus our minds on the overwhelming amount of data we must process each day.

As a child develops, however, sensory processing takes place at the highest level. Young children cannot and do not see the need to hold back an expression of honest feelings. Because their forms of communication are limited either by their inability to speak words, an inadequate vocabulary, or because of their early physical development, they react much more expressively with their bodies and facial expressions. These expressions, according to Stacy, are what define a child's visual (and hence, photographic) personality. Knowing how to extract them using sensory input is the key to getting great photos.

JOURNAL THE EXPERIENCE

In the short span of a portrait session, how can you pull out the expressions that parents see on a daily basis? To start, the photographer must be sensitive to children's experience of the world, understanding that children must feel safe and secure to really "act naturally" in front of the camera.

Infants and toddlers tend to seek out activities that provide sensory experiences that are beneficial to them at that point in their development. They will, however, avoid being placed in environments that make them feel uncomfortable or unsafe. How quickly a child objects to a certain photo set or how loudly he screams to be taken off the set comes from his internal temperament and his coping ability on that given day.

Keep in mind that, as adults, we get choices on what sensory input we would like to receive and which environmental conditions we wish to avoid—and in most cases we accommodate our own needs. Children, on the other hand, do not have the ability to choose their environment, nor do they have cognitive skills to interpret why they are uncomfortable in certain situations. That means it's up to you (and the child's parent) to determine what constitutes a pleasant, interesting environment for the child at that point in time. To better understand this, you may find it helpful to study and journal your experiences after each photo session. This practice allows you to collect data on what works and what doesn't.

ANOTHER PERSPECTIVE

Stacy Bratton's friend and assistant, Maureen Mann, has been in the photography business for over twenty years,

In this priceless portrait by Stacy Bratton, the photographer had the child look back toward the open sky to produce beautiful and soft lighting. Notice, too, the very shallow band of focus created by shooting at the lens's widest aperture.

and her children's-portrait philosophy was that you get what you get based on the child's mood that day—and you better get it quick! This perception changed dramatically when she began assisting for Stacy. Maureen says, "Stacy is known for the incredible variety of expressions she coaxes from children. I imagined her sessions were similar to others I had been a part of—quick and fun but frantic and with a lot of luck involved. I was wrong. She uses her knowledge of child psychology to control the situation and elicit the expressions she desires."

According to Maureen, "Sometimes it is hard to watch. The first thing I discovered is that the child is not allowed off the set unless Stacy allows it—no matter how sad the cry, emphatic the scream, or worried the parent. She allows the parent to go on to the set and comfort the child if needed, but the parents may not remove the child, nor pick them up.

Maureen continues, "By using toys and distracting play methods with bubbles or feathers, Stacy changes the behavior being exhibited, and retains control of the

Expressions like this are not unusual from a Stacy Bratton photo shoot. Children in the 7- to 12-month-old category can sit up and are more alert than younger babies. Stacy says of this age group, "Eight- to 11-month olds are one of my favorite age groups to photograph. They are very social, very happy and not yet mobile."

shoot. The end result is a wide range of expressions—and, of course, she snaps a few of the crying moments to round out the personality series. By maintaining control of the set, not rewarding manipulative behavior, and using fun as an incentive she consistently achieves the wide range of expressions for which she is sought after—and children look forward to returning to the studio."

Stacy was surprised by what Maureen considered a hard-line approach. She says, "It made me think, 'Wow—I thought it was common sense to not let the child control the situation. And, of course, no one should reward misbehaving. Good behavior gets great rewards and bad behavior gets . . . well, *nothing*. Once the toddler learns that, all I have to do is find out what motivator is stronger than their will to object. And I am strictly referring to *toddlers*, not babies under ten months old."

PHOTOGRAPHER PREPARATION
Stacy has a very definite approach to each new situation. She says, "Never approach a child and start speaking to them without speaking to the parent first. Don't put a child on the spot to have to 'like you' or even have an interest in you. A child will probably wonder what you represent to them. They may be frightened that you are a babysitter or teacher—they might think 'Mommy might leave me here' or wonder if they are going to get a shot."

The idea is to have Mom introduce you to the child. When you say hello, watch how the child immediately looks at Mom for non-verbal clues ("Do we like this person or is this person a threat?"). Very young children, under 9–12 months, cannot even distinguish themselves as individual beings from their mother. Therefore, they cannot be expected to cooperate fully if they do not have a mother or close caregiver to give them visual clues and guidance on how to feel about a situation.

Children will mirror the parent's internal feelings. Stacy warns, "Nervous moms make nervous babies. Do everything in your power to make the parents feel good about their choice of your studio and remind them of their power over the child's feelings."

After the introduction is made, Stacy suggests that you do not take a serious interest in trying to be friends—that is too much pressure for a child. Instead, show them some toys you have set out for them. Let them know that your house and your toys are for them to play with. "If your studio is set up right, a child will want to get to those toys immediately," she says.

STUDIO SETUP AND SCHEDULING
Have the front room in your studio set up in a way that feels more like a home than a place of business. For photographers photographing primarily children and families, this is a great way to disarm any anxiety that may exist for adults, and create a better environment for a child to meet a new adult. Says Stacy, "To the child, it feels more like they are visiting one of Mommy's friends." Traditionally, parents think of professional photo sessions

AN EXCEPTION TO EVERY RULE
Stacy notes emphatically that everything about her behavior and that of her tiny subjects is subject to exception. "How children behave and how I manipulate their behavior has been negated by at least one child in every area of discussion. Once I feel confident that I understand exactly what to do with a certain age of development, a child walks in the door who breaks all the rules."

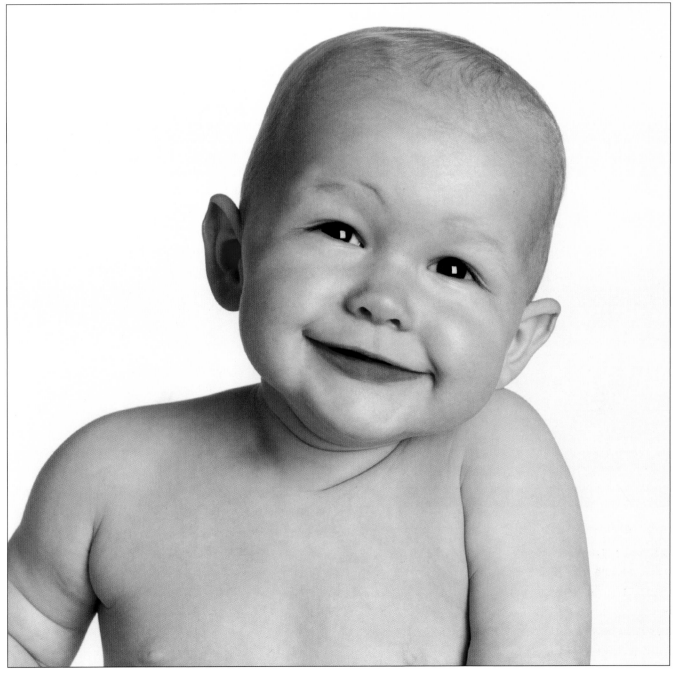

While Stacy's rules might seem a bit daunting at first, especially to new parents, when they pick up their proofs, they see the best portraits ever taken of their child.

around their child's birthday—but they also schedule their immunizations this same month. Therefore, it might is wise to ask the parents when those doctor's appointments are scheduled and try to schedule a booking prior to that date.

BEFORE THE SESSION

Parent Preparation. Prior to their arrival, Stacy's assistant will suggest that the parent does not talk too much about the photo shoot at home. It is okay to mention it,

just don't dwell on it. Stacy says two things can go wrong here: (1) the child may use it against the parents when trying to manipulate the situation, and (2) it puts a tremendous amount of pressure on the child to "perform." She says, "I have seen this many times. A child will talk and talk and talk about some event coming up and then freeze—refusing to perform when the event happens. I'm not sure why, but I'd guess they have built something up so big in their minds that they eventually scare themselves."

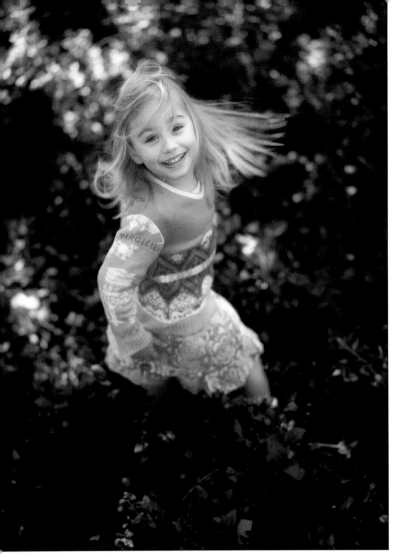

This photograph by Stacy Bratton is indicative of why parents hire professional photographers to create portraits of their children. This is such an innovative image—and it's made even more effective by shallow depth of field and a relatively slow shutter speed that blurs the child's hair. Everything about the image is original and fresh.

Immediately before every photo session, Stacy has a chat in the front room of the studio with the parents, grandparents, or whoever is joining the photo shoot. She makes sure the child is in the room and getting more and more comfortable with the sound of her voice, hearing her speak with the parents in a positive tone. "I have this same chat, even if the parents have been to my studio many times before, because their child has changed in development from prior photo sessions and the child's expected behavior, as well as my style of 'running the show,' changes with every developmental stage," says Stacy.

Having the Set Ready. For all baby sessions, Stacy suggests that you have everything ready before the session—and that you do a few test shots. Stacy has a "stunt baby" who stands in for lighting tests and color balance.

STACY'S SIX RULES

Through experience, Stacy has come up with several rules that her studio applies to all children over the age of one. She goes over the rules with the parents so that they can be prepared for her different techniques, which at times seem may seem counterintuitive. She also forewarns the parents that some crying will be expected, but "we have all kinds of interesting games with which we try to engage the child into playing with us, and Mommy can always stay with the child during this time," she says. In fact, Stacy will engage Mom in all the games. Stacy chuckles, "We all just sit around the set playing different games until our little subject decides he or she wants to be in the game as well." This technique works well, according to Stacy, and can take anywhere from one to thirty minutes—on the average, though, it only takes about five or ten minutes for the child to get curious enough to join in.

1. Miss Stacy is the Boss. Once in the studio, kids soon learn that this is Miss Stacy's house and Mom and Dad are no longer in charge. Of course, the client is in charge of many of the aspects of the photo shoot, but the child must not think that they can manipulate their parents into getting what they want. This immediately relieves the burden of the parent having to say no to everything the child requests. Most kids respond and behave better for adults who are not their parents.

If a child begs his mom to let him have a sip of her soda, Mom directs the child to ask Miss Stacy. Rarely (one in a hundred kids, according to Stacy), does this produce tears when she says, "No, that it is not a good idea right now because we might get our clothes wet." They accept Stacy's answer and wait until after the photo session. Similar requests by children can be used during the photo session when Stacy needs a little cooperation. She'll say, "Remember, we have to finish the photo session before we can have some of Mommy's soda pop—let's hurry."

2. The Shooting Room is Off Limits. Children between the ages of one and three must be carried into the shooting room and are not allowed to walk around and explore until they take a break or the session is complete. Stacy's shooting room is off limits until the session is about to begin. If the child is too comfortable in the photography room, they often feel they can roam around and explore. Because the studio is filled with different back-

grounds, toys, chairs, and interesting camera equipment, a child could have a real good time without ever coming to the set.

Stacy says, "Depending on the child's age, prior to entering the studio we will talk about the 'bubble room,' which is where all bubbles are blown. Most verbal children will ask to go in there. I tell them we cannot walk into the room, but Mommy must carry them. Then, Mommy and child will get to chase, pop, and kick the bubbles. My assistant is waiting with the bubbles ready to go. If the child can ask for them, all the better. 'Please, bubbles!' may be all that the child says, but we have now established that we have control over the child, and the child feels like they have control over the bubbles."

3. The Child Stays on the Set. Stacy does not allow the child off the set until she is finished or they are taking a break. Most children have learned through experience that if they fuss long enough they will eventually get their way. Instead of allowing the child to leave the set, Mom or Dad gets on the set to comfort the child—they just cannot hold them in their lap.

The best photo sessions, says Stacy, happen when an incredibly willful child vacillates between wanting to play and not wanting to play. With these kids, Stacy says, "Once the initial session has started and everyone is happy, we still need to stay very energetically engaged. I must change up the games or playing as frequently as the child gets bored. So plan on having lots of different activities to interest the child."

4. Parents Must Stay in Sight. Parents should never be out of sight of the child. Stacy advises her parents not to go behind the camera stand or big lights. If they need something from the car, one of her assistants will go get it so the parent can stay visible to the child at all times. It is especially helpful when a parent sits on their knees in front of or beside the camera stand. Kids feel more comfortable when it's clear that the parent is staying put. "This rule is bendable if the child will not stop clinging to the parents," says Stacy.

5. One Voice at a Time. During a photo session, only one person at a time should speak to the child. Too many voices can be confusing; the child will not know who to

Newborns are not alert much of the day, so Stacy tries to schedule a session around a feeding. All nude newborn photos start with a fully swaddled, fully fed baby. Stacy gradually removes the layers of fabric surrounding the baby until the baby is uncovered.

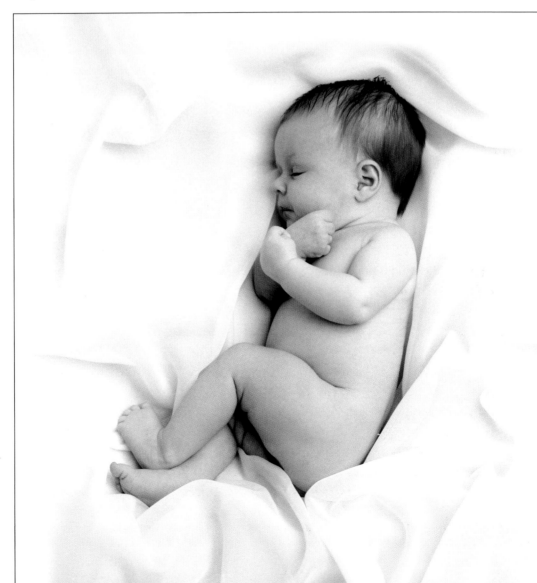

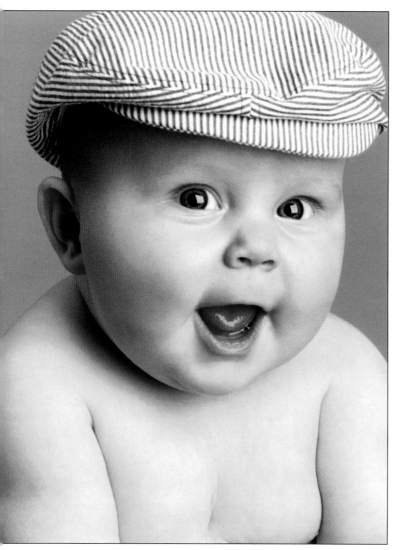

Stacy has devised a number of techniques designed to effectively stimulate this age group (six- to eleven-month-olds). This little guy's expression is priceless.

look at or respond to. This is also the reason Stacy does not like to turn on music.

6. Toys are Concealed. All toys and playthings, whether they belong to the parents or the studio, should be out of sight during the photo session until the photographer gets them. In advance, Stacy will ask the parents if they have brought any of baby's favorite items and if they wish to have them photographed. Most parents bring a favorite toy that always makes the baby smile, but they do not want it photographed. Also, most parents will bring the baby's "lovie," such as a teddy bear or blanket. Baby's favorite toys or "blankies" are great to have around, but they aren't Stacy's first choice, because they represent something too familiar for the child. Favorite "lovies" should be out of the child's view until chosen by Stacy when the timing is right.

Newborns. Newborns have not yet become very alert at any time during the day. They sleep and barely eat for the first few days, sometimes weeks, after birth. Stacy's unofficial definition of a newborn is up to eight pounds or three weeks—whichever comes first.

Ideally, a session is scheduled to begin about the same time that a scheduled feeding begins. Stacy recommends that mom put her sleeping baby in the car and feed the baby at the studio just prior to the session beginning.

Stacy cautions, "Before handling a newborn or any young child, wash your hands carefully in front of the parents. Have your assistant do the same. Pay special attention to your fingernails. Not only is this the right thing to do with a new baby, it is an important step in getting a parent to trust you."

Naked Babies. When a baby comes into the studio for a "naked baby" session, Stacy or her assistant takes off the baby's diaper and socks immediately. These items of clothing produce red indentations on the baby's skin and are not fun to retouch. Stacy also suggests that mothers bring their babies to the studio in full-length pajamas or something else that minimizes marks on the skin—these can take up to twenty minutes to go away.

During the session, cloth diapers—which the studio uses by the dozens—are placed under the baby to avoid changing the set too often during a session and to keep the parents, photographer, and assistants dry. With nude sessions, Stacy also turns on two heating units, one on each side of the set. Her assistant constantly checks the temperature around the child's head and body.

Babies are fully swaddled to start these sessions. Newborns have just come from extremely tight quarters. As a result, the startle reflex—when the baby's arms flail out from their bodies—is strongest in the first few weeks of life. This creates a feeling of free falling for the baby, so keeping their hands pinned and tucked under their bodies or within a blanket makes them much more comfortable. Once the baby is asleep, Stacy slowly unwraps the blanket. During the shoot, Stacy's assistant stands a few inches outside of the set with a blanket ready to re-cover the baby.

Many babies that Stacy photographs straight down are actually sunk down into blankets that keep them in a curled-up position. The way she sets this up, you can't tell that the baby has been placed lower than the sur-

rounding fabric. This is the only way she can photograph twins and keep them close together.

Tools and Tricks. Stacy says, "I have a set of eight musical bells with the sound range of one octave. If a baby is awake, he or she will look towards a bell that I ring near the camera. This will only work once or twice; once the baby registers a new sound, they no longer need to search for it. This is why I have all eight tones on the set. If I change the tone, the baby again will start to look for the new sound with wide eyes. I can usually get a newborn to look directly into the camera with this technique."

It's not an old wives tale that babies really do like high-pitched voices better than low-pitched ones. Remember this when you are speaking to a baby.

Have a pacifier or mom's finger at the ready. If baby wakes up or seems to not be able to lie still, the act of sucking a pacifier (which will need to be held in baby's mouth; their tongues are not yet coordinated enough to hold it in place) or mom's finger should calm the baby.

Electronic Flash. Some babies decide the first electronic flash is the last flash that they will tolerate, so make sure your first photo is a great one. It may be the only one you get, but you only need one! For newborn sessions, Stacy's strobe heads are powered down to a fraction of the power they can produce. "Newborns are not going to move around much, so I am not as concerned with depth of field," she says. "If the flash burst is too loud, though, you will likely agitate a newborn's nervous system." Stacy also recommends turning down the modeling lights and turning out the overhead lights. Stacy says, "I will even cover a baby's eyes with a cloth diaper until it is time to take pictures."

Dos and Don'ts. Never lightly stroke a baby's back, this agitates the nervous system. "Newborns are used to very jerky, bouncy movements from in utero," says Stacy. "Light touch, especially a surprise light touch from behind or when asleep, actually results in a 'fight or flight response.' Instead, a firm pat on the back will calm a baby," she says. Stacy has also been known to hold the baby's bottom and gently shake it back and forth. It mimics the baby's sense of mom walking before the baby was born.

Newborns have been living within a noisy environment. Making a "hushhhhhhhh" sound (holding out the "shhhhhh") very close to a baby's ear usually calms the child. The sound is similar to the ocean sounds on an en-vironmental sound machine—and Stacy admits to owning one of these for babies who respond positively to this form of sensory input. (*Note:* Mom can do this, but the sound of her voice will usually make the baby want to be picked up.)

Six-Week-Olds are Double Trouble. Six-week-olds are very difficult to photograph. The newborn sleepiness has worn off and, under the conditions of a photo studio, the child can stay awake for hours at a time. Then, they become agitated and unable to relax. They are unable to smile or their smile is disorganized, and their eyes will cross frequently due to the flash. Stacy prides herself on

U-shaped baby posers, available at retail baby stores, make the baby appear to have more head strength than he really has. Notice this wild hat from Stacy's collection. Who knows why babies like her hats so much—but they do.

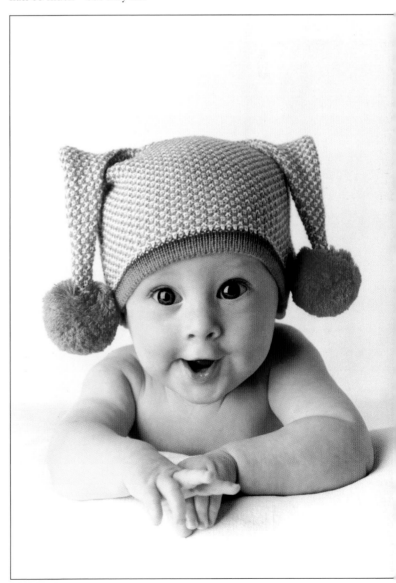

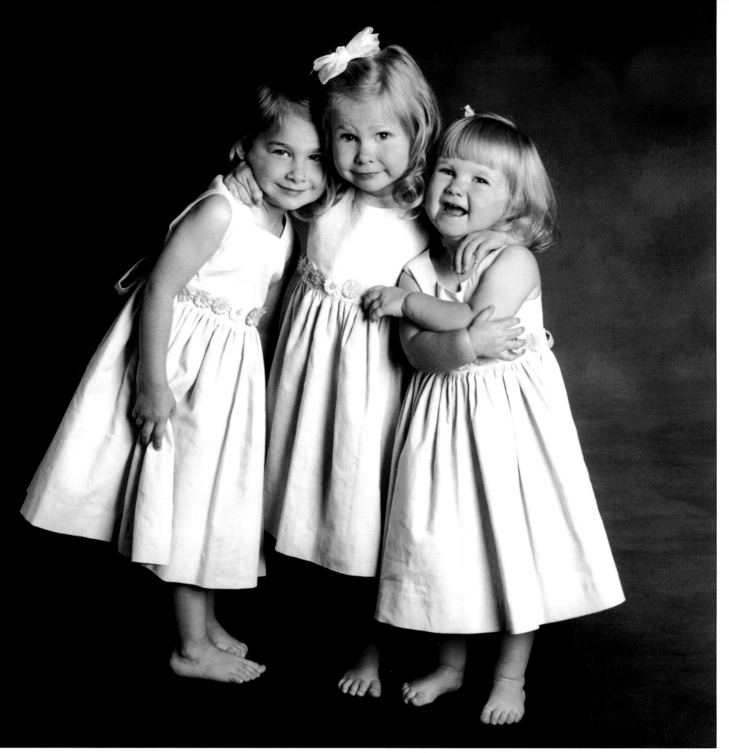

Stacy is a gifted at working with kids of all ages. Here, three sisters in their matching dresses are willing participants in Stacy's friendly system of "subject management."

photographing even the youngest babies, but she tries to avoid working with six- to twelve-week-olds.

Three to Six Months. Babies of this age will rarely fall asleep during a session—unless you are prepared to stay with the family for two to three hours.

One important thing to remember about babies of any stage of early development is that many physical activities require much attention from the baby to achieve. As

a rule, babies can only perform one voluntary physical feat at a time. For example, Stacy warns parents that when she puts a baby on his tummy, he is usually working so hard to pull his head up, that a smile may not be possible. Babies in this position may smile, but at the same time their heads drop straight down.

At the parent's request, Stacy will photograph many three- to four-month-olds in this position; but she also

takes the time to photograph the baby on his back, with the camera looking straight down. If a three-month-old does not have to work to keep his head up, he can move his energies into a smile or conversation with you. Trying the tummy route first can backfire, though, because the baby may be too tired to go on after that. Sometimes a little food between the two sets can be very effective.

Some babies have adverse reactions to being on their tummy. A good question to ask a parent prior to a tummy photo session is if their baby will tolerate this position.

Props. To help a baby hold their head up while lying on their tummy, you can buy U-shaped baby posers, found at all retail baby stores. Stacy covers hers with fabric. "I place the baby face forward with his feet dropped down lower than his head," she says. "My camera is lower than the baby's head. This gives the baby the appearance of having more head strength than he really does, because he does not need to lift his head as much to see me."

Six- to Eleven-Month-Olds. Traditionally, parents first have their child photographed at about six months of

This child, who is in the seven- to twelve-month-old category, is making an expression that one could assign to an adult. The range of expressions at this age is phenomenal. Portraits like this are proof that a child doesn't have to be smiling for it to be an effective portrait.

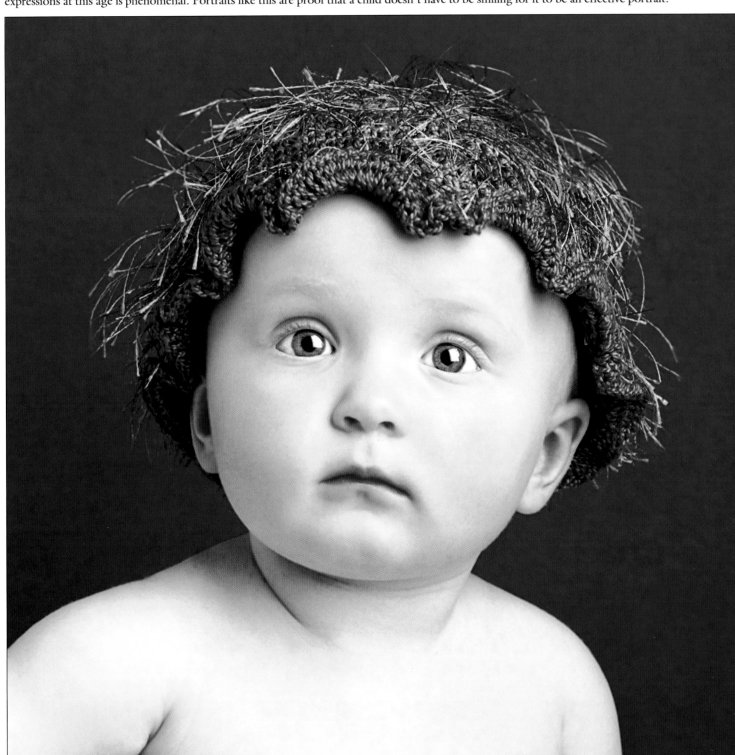

age. Somehow, most people—including parents—think that a child should be sitting up unassisted at that point. According to Stacy, "This is not true for 75 percent of babies I photograph. If a parent wants a classic baby photo at six months of age, and wants to include the baby in a sitting-up position, I talk them into photographing the baby at the *end* of the six months (right before the seventh month date). This should ensure the baby is sitting up unassisted."

Ask the parents specific questions. "Can your baby sit up and hold a toy in one or both hands and shake the toy and smile at you?" "Can you tap on the baby's shoulder without knocking the baby over?" If the answers are no, then baby cannot handle sitting up, seeing a large flash, and smiling at the same time. If a baby has not achieved true independent balance, he will usually fall backwards when he tries to smile, move his arms, or experience the light flash.

Stacy says of this age group, "Eight- to eleven-month-olds are one of my favorite age groups to photograph. They are very social, very happy, and not yet mobile. Once you determine the right way to communicate with

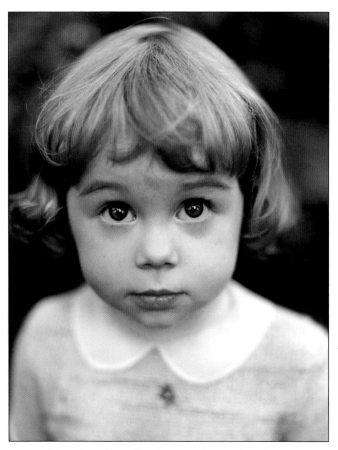

Many of Stacy's tricks and techniques that work with very young children also work with older ones—here, a curious three-year-old.

a baby around this age, most are happy to sit and play—and they do not yet have an interest in crawling away from you to explore."

Copycat. Mimic the baby's noises. If a baby manages to make a noise, any noise, they are communicating with you. If you can mimic that noise back, you have validated their hard work and acknowledged their attempt at communication. This creates more smiles than anything.

Coax a Smile. For a younger baby who is "on the verge" of a smile, but just does not seem to be able to do it, just rub a burp cloth over the corners of their mouths. Sometimes they simply need reminding where those muscles are. Younger babies may require that for every smile during a session.

Predictability. Babies of this age (and up to two years) enjoy predicting the next thing you will do. If they predict correctly, they are usually pleased and will smile if the physical conditions are right. Stacy will set up patterns of behavior that she will repeat several times. Then, the baby can start to predict what her next move might be.

Peek-a-boo is a great example of this—you hide behind a blanket and they predict the blanket will drop down and show your face. Stacy also hides behind her light box and pops out from behind it. If she pops out from a different side of the box, the predictability has been broken—and this evokes either a surprised or a confused look. "If a baby follows my feet under the light box, they can then predict what side I will pop out from," she says. "What an accomplishment!"

Rubbing Baby's Gums. Since babies are teething on and off through their entire first year (and also since they explore everything with their mouths), Stacy often rubs their gums with a burp cloth in a fun and playful manner. This does three main things: it focuses the baby's attention on you and the camera; it satisfies their need to touch things with their mouths; and, even more importantly, it pulls out some of the drool that was just waiting to run out as soon as the baby smiled.

Wind. Try waving a piece of foam-core up and down or side to side to create a wind effect across the baby. Start soft and far away in order to gauge the reaction.

One- to Three-Year-Olds. While Stacy and her assistant are arranging the mother near or with the child on the set, she or her assistant will blow bubbles towards the child. She cautions, "Do not let them hold the wand or you will never get it back without a major battle."

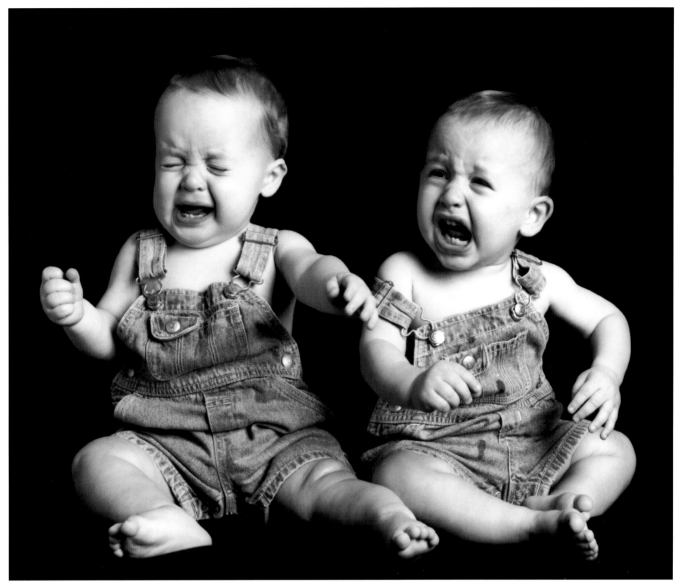

Stacy Bratton is a whiz at working with kids but sometimes even the best-laid plans fall short. In this portrait, it has become stereo hysteria and the only thing to do is to get a good image. Parents will often appreciate this kind of image of their kids as much as the cute, smiling ones.

She also mentions to parents that if a toddler sees a new toy of hers, a favorite toy from home, a pacifier, a stuffed animal, or a blanket, they almost always need to have it in their hands right away. So be careful what you bring to your camera stand! Young toddlers, especially one- to two-year-olds, can be so fixated on what they want that they simply cannot wait to handle and explore it. Until they are two to three years old, children do not have the emotional ability to "wait a few moments."

Distractions. Arriving on the set, the first reaction from children of this age is generally "No! Got to get down now!" This usually happens before the first photo is ever taken. "This is generally where my crying and frustrated photos come from—the beginning of the shoot rather than the end of the shoot," says Stacy. "But, we do not let them down unless they are truly terrified—and there is a different, desperate, panic cry that comes with that emotion." With mom on one side of the chair, her assistant on the other side, and Stacy in front of the toddler, they work with balls of all shapes and sizes and, play catch, pop bubbles, read books, and sing songs that have hand gestures. This usually gets the child over the initial hurdle of being on the set.

Stand on the Tape. When a full-body set is called for there is no way to contain a toddler except with positive reinforcement and some distraction. On these, sets Stacy puts a piece of colored tape where she would like for the child to stand. They are to cover the piece of tape like a

Stacy's containment box comes in handy as a posing bench for these two cowboys. One of main ingredients of Stacy's portraits is the great variety of expressions. She says she gets at least sixty different expressions from an average photo session.

Stacy's techniques are designed to stimulate a child in a positive and safe way. She goes to extremes to create a welcome and happy environment. This two-year-old seems to appreciate the effort.

game of hide and seek. Stacy says, "We will stomp the piece of tape, touch it with our fingers, spin on it, etc. It becomes a focal point to distract the child from leaving the set." They have one rule: never get off the seamless paper—and don't let Mommy off either.

Stacy also has some favorite requests to get the child motivated. "Go to your spot and I will tickle mommy with the feather," she'll say. Or she might ask, "How high can you jump? Show me while you are standing on your spot!" Here's another technique—and it sounds bizarre, but it works: "Holding from behind, I pick up the child and spin him around in circles and then see if he can 'hide' the piece of tape with his foot. It is unbelievable! It works every time. (They are also quite dizzy and cannot move from that area yet anyway.)"

Stacy repeats her disciplined stance with compassion, "It is hard to listen to a child fuss for even five minutes, but if you let them off the set just because they would rather play on the floor, the next time they are put on the set, they will fuss even longer. Do you know why? Because, it worked the first time. The child knows that your will power is not as strong as his or hers." Game over.

Climbing. "If all else fails," says Stacy, "get some type of chair or box and put them in it to climb out—or challenge them to climb in. If I put a chair down in the set, I will have my assistant, Mommy, and myself sit on the chair in succession. I never ask the child to sit in the chair, but they are *very* sure that they are supposed to have the chair and not the grown ups. So guess what? They want to sit on and possess the chair for quite a long time."

Turn off the Overhead Lights. Another excellent trick with mobile toddlers is to turn off the overhead lights. Says Stacy, "My studio becomes very dark if I turn off the overhead lights. Occasionally, this will scare a toddler and the lights must remain on. But I have learned through experience that a toddler cannot see past the light box after a few flashes have been fired. If they do not know what is there, they are less lightly to want to go to it."

The Tickle Feather. Stacy's tickle feather (a bunch of feathers on a stick) is used for every age group except newborns. For a child between the ages of three and seven months, the feather is used as a focusing object to direct the child's gaze toward the camera.

As a child is able to sit up, it becomes more useful and fun. Usually the feather is introduced by showing it to Mom first. If Mom then introduces the feather to the

Here are eighteen-month-old twins with the containment boxes. They are a good example of very difficult children who needed a distraction and were not cooperating very well. Stacy's containment box was the only tool that would work.

baby, the child is more likely to have fun with it—and less likely to be scared.

Stacy guarantees your subject has never seen or felt anything like this feather. For a six- to twelve-month-old, it really does "tickle" the feet and sides. Don't move it too quickly toward the face—this scares the child. Instead, move slowly from the feet up to the side of face.

For a one- to three-year-old, it's sometimes fun to tickle Mom. Ask them, "Would you like me to tickle Mommy?" Most of the time, this is absolutely hilarious to a young child.

The engaged toddler will start asking for the different toys that have been brought out and request they be used. If they say "ball," play catch. "Bubbles," and you or your assistant blows bubbles over the set. "Tickle Mommy," and Mommy gets tickled. It gives them so much control and power. Just move very quickly, they will cycle fast through your toys. Another type of child

Stacy uses a set of eight musical bells with the sound range of one octave. If a baby is awake, he or she will look toward a bell that Stacy rings near the camera. This will only work once or twice; once a baby registers a new sound, they no longer need to search for it. This is why she has all eight tones on the set. If she changes the tone, the baby will again start to look for the new sound with wide eyes. Stacy says, "I can usually get a newborn to look directly into the camera with this technique."

just wants to hit things—including the feather. Let that work for you. Usually this toddler loves slapstick humor and extremely loud noises.

Taste. Stacy uses taste as a huge motivator for toddlers of all ages—as well as a funny face amplifier. If a six-month-old hates to be on her tummy and cannot do anything but fuss and cry, try putting a tiny dot of sugar on the end of her tongue. This will distract her and perhaps change her behavior. This technique has about a 50-percent success rate with six-month-olds, but it works 90 percent of the time with two-year olds.

"Don't use sugar during a photo session until absolutely necessary," Stacy warns, though. You can never go back once the candy has been brought out." Do not let Mommy control the candy. "I don't need to tell you that for an eighteen-month-old child, candy will make

you their best friend. But they can become quite demanding and very upset quickly if they are willful, tired children," she notes.

Loud Noise vs. *Soft Noise.* A loud noise (not from a person but from an object) will often stop a fussing child. You can almost guess that a child is not really upset when any distraction that comes their way stops them from fussing long enough to see what is going on. You might need to be very loud for the baby to hear you.

A soft noise will make a toddler look at you with great interest—especially if they are already verbal. If they are new to speaking, try to understand what they are saying. New talkers love to converse.

Ask Familiar Questions. Ask the parents what names the child will recognize—including pets, siblings, etc.—then formulate some questions. Asking, "Where is Buster?" or "What sounds does Buster make?" you'll often get a quizzical looks. The child will wonder, "How do you know that I have a dog?" Engage them in questions they can answer verbally ("What is your sister's name?") or even by pointing ("Where is your nose?")

Use Reverse Psychology. Say, "Don't touch those bubbles," then act surprised when they do just the opposite. You can even try, "Don't lift your shirt to show me your belly button," and of course they will do it with a humor of defiance. Try overreacting with a statement like, "I can't believe you did that. Stop doing that to me!"—or whatever gets a laugh.

Try Slapstick Humor. Toddlers have two different reactions to slapstick type humor. Some very much enjoy seeing the photographer feign a ball hitting their head, running into the light or camera stand, or something else just as silly. Most will also like to see their parent engage in this same behavior. However, there are a few very protective toddlers out there who will get extremely angry if you do even the slightest joke with a parent.

Clothing is really the best form of "prop" for a child's portrait. Fine clothing, like a christening gown, can define the moment. Other clothes, like jeans and a cowboy shirt, can define personality. A child's best clothes are always handpicked lovingly by Mom—and

the children adapt an air of confidence when they are dressed in "Mom's favorite" clothes. There is something beautiful and memorable about a crisply dressed child with his or her hair combed neatly and dressed in their finest clothes. It's special for the parents and the children—and it usually doesn't happen very often. Keep in mind, though, that very little children can sometimes get lost in their clothes. Sometimes it is just as appealing to show a little skin—arms, legs, and most definitely hands.

UPSCALE OR AVERAGE

Portrait photographers Brian and Judith Shindle believe in the upscale prop. Several years ago, Brian purchased a christening gown from Nieman Marcus for $1500. It is the studio's way of enhancing the timeless quality of the child's portrait and can enrich the portrait experience from the client's perspective, making the session more gratifying. However, such elegance is not without risks. Every time Brian takes the gown out of its special bag, he hopes his little client won't throw up all over it.

CONSULTATION MEETING

Clothing should be discussed and coordinated during a pre-session meeting. All of the specific items for the shoot should be coordinated with the clothing, so that props like blankets and stuffed animals have colors that com-

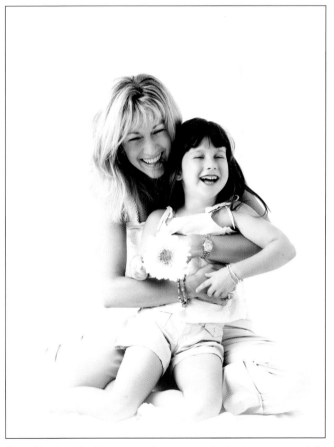

Coordinating clothing can make a very cohesive image, especially in a mother-and daughter portrait. Note the similarity of outfits right down to the beaded bracelets. Of course, it's the priceless expression that really makes this portrait a success. Photograph by Jim Fender.

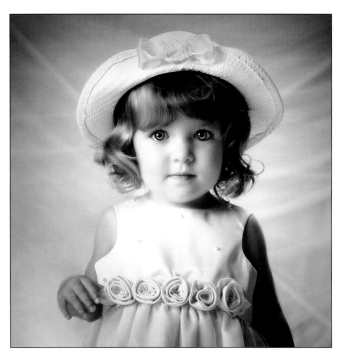

ABOVE—Consultations prior to the portrait session are essential so that parents will not be disappointed and so that the photographer can coordinate backdrops, props, and lighting. Here, Jeff Hawkins used a pink chiffon background that matches this little angel's formal dress and hat. Even her hairstyle matches the wardrobe and setting.

FACING PAGE—Brian Shindle is a master of coordinating clothing to create a formal shoot. Every detail of this girl's clothing is carefully orchestrated and coordinated, right down to how the knots are tied in her ballet shoes. Brian does not go for the big smile in his portraits, favoring instead the subtle expressions that reveal character, in the style of the expatriate American portrait artist John Singer Sargent.

plement one another. When photographing children outdoors, it is important to dress them in clothing that is appropriate to the setting and the season. For example, if the photo is going to be made in an elegant wood dining room, don't arrange for the child to wear shorts and sneakers. A child's portrait is meant to be enjoyed for generations to come. Fad-type clothing should be avoided in favor of less trendy, more conservative dress.

Arrange for the parents to bring more than one outfit. At least one outfit should be all solid colors without designs. If more than one child is being photographed—a brother and sister, for instance—clothing should be in complementary or matching colors. Gaudy designs and T-shirts with writing (or worse, cartoon characters) should be avoided. As Suzette Nesire notes to clients, "Keep in mind the final images will be presented on your walls in your home. No stars and stripes and as few logos

as possible." Also, new clothes may not be comfortable for the child, so you may want to start the session with the child in casual, familiar clothes and work up to the dressy outfit.

People don't realize that the wrong selection of clothes can ruin the photograph. That is why it is so important to discuss this prior to the session. Having to re-shoot the portrait is costly and inefficient for both the customer and the photographer. Below are several topics that should be covered in the consultation.

Dark and Light Colors. Darker clothing helps to blend the bodies with the background, so that the faces are the most important part of the photograph. As a general rule, dark colors slenderize the subject while light colors seem to add weight to the bodies. While this point is usually not a factor with children, with some overweight or skinny children it could be.

The color of the clothing should always be toned down. Bright colors pull attention away from the face. Prints and patterns are a distraction and, in the case of digital portraits, small patterns (even small herringbone or checkered patterns) can cause unattractive moiré patterns to appear in the fabric.

Glasses. You see more and more children wearing eyeglasses these days. For the child's portrait, glasses may or may not be worn, depending on the parent's or the child's preference. Non-reflective lenses are helpful to the photographer, who will be restricted as to the lighting setup when eyeglasses are a part of the portrait. Sometimes it's possible to obtain a matching set of frames with no lenses. This is particularly helpful if the child's glasses distort the outline of his or her face.

Shoes. Shoes are often a problem on small children. The soles are usually ugly and they can sometimes dominate a portrait. Most frugal parents purchase shoes in the hope that they will "still fit in a month," so they are often a little loose and look large. Some photographers, if the scene and clothing warrant it, will have the child remove his or her shoes—after all, children's feet can be cute.

Hats. The child will often feel right at home in his or her favorite hat or cap. When working outdoors in open shade, hats provide some overhead blocking of the diffused light—like little overhead gobos—and minimize the overhead light on the child's face. In the studio, you must be careful to get light under the brim of the hat to illuminate the eyes.

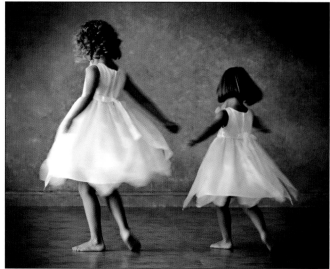

Vicki Taufer specializes in photographing children, families, and seniors. Her children's portraits are really special, as she seemingly has an inexhaustible standing wardrobe department with all the costumes and accessories a kid could want. In the portraits shown here, you can see that not only is it important that the child look wonderful in a Vicki Taufer portrait, but that the image also have style and even a degree of a fashion edge to it.

Exotic hats are always a big hit with kids and range from pointed wizard hats in bright colors to little sailor's hats. Stacy Bratton has a collection of ridiculously cute knitted hats. They are silly, colorful, and pretty goofy in general—but the kids seem to love to wear them in her portraits.

PROPS AND COSTUMES

Fantasy Costumes. Some children's portraits involve dressing the kids up as fairies, mermaids, angels, or other mythical characters. As a result, the "property departments" of many studios are brimming over with costumes, hats, veils, boas, feathers, angel wings, and more. These need to be loose fitting, so that they can be adjusted to fit any size child. Fairies are a popular fantasy, so

items that can enhance a basic costume are always valuable. Of course, a wide variety of costumes are also available commercially from many sources. Small children are often photographed bare-footed so that the child's shoes don't spoil the illusion.

Fabrics. Many children's portrait studios maintain an extensive supply of vibrantly colored fabrics—cotton, linen, burlap, mesh, gauze, and just about any kind of exotic cloth you can think of! These fabrics can be draped beneath or around the child to fashion a costume or loosely pinned to form a smock or gown, depending on the material.

Forest Scenes. Props for these portraits might include logs, rocks, or tree stumps (all artificial, lightweight, and commercially available). These are used to build a forest scene or wooded-glen set, for example. To garnish the portrait, artificial leaves, plants, and flowers can be positioned near and around the children. Small props, like woodland animals, frogs, butterflies, birds, and so on are also used to add to the illusion of the fantasy portrait.

Small garlands of artificial flowers are often used as headbands. Garlands are also sometimes loosely arranged within the photograph as color accents.

Antiques. Small antique suitcases are also a popular prop, used to create the illusion that the child is traveling to some exotic location. Some studios also have antique rocking horses, tricycles, and more—stuff the photographers have picked up over time.

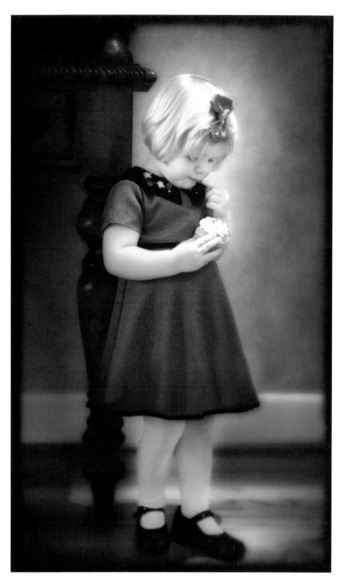

LEFT—A flowery sun hat seems to suit the personality of this beauty. The image was made in available light and treated with the LucisArt plug-in by Cherie Frost. Photograph by Frank Frost.

ABOVE—Everything in this photograph by Kersti Malvre, entitled *Cupcake,* is perfectly coordinated. The large, dark furniture is barely visible, but gives the portrait scale—and the little girl's outfit is delightful.

BACKGROUNDS

Along with a wide range of props, costumes, and accessories, the photographer offering this style of portrait must also have a wide range of hand-painted canvas backgrounds, which are available through many vendors. These backgrounds are usually done in pastels or neutral tones to complement brighter shades used in the children's costumes, and can be either high-key or low-key in nature. Sometimes, the details in these backgrounds are purposely blurred so they do not attain too much visual attention in the photo.

Some photographers even hand-paint their own backgrounds using acrylics and a thin-gauge canvas. Other photographers use soft muslin backdrops that can be hung or draped in the background. There are even "crushable" painted backgrounds that catch highlights and shadows in their folds and wrinkles, producing a dappled look.

9. OLDER CHILDREN, TEENS, AND SENIORS

Photographing older children requires a different mind-set than working with small children and babies. Adolescents and high-schoolers require patience and respect. They also want to know the details—how long the session will take, what is involved, etc.

CONSULTATION
When you meet with the teen and his parents before the photo session, suggest that he bring along a variety of clothing changes. Include a formal outfit, a casual "kickin' back" outfit (shorts and a T-shirt), an outfit that is cool (one that the senior feels they look really great in), and an outfit that represents their main interest (a sports uniform, etc.). You can also encourage kids to bring in their favorite items—or even a pet. This will help reveal their personalities even more and, like small children, the presence of their favorite things will help them feel relaxed and at home.

NO PARENTS AT THE SESSION
Teens probably will not feel comfortable with a parent around. Instead, ask them to bring along a friend or two and photograph them together. Most parents still think of their teens as little kids, not young adults. As a result they often make them feel self-conscious and awkward—the last thing you need when you make their portrait. You need to assure the parents that, by excluding them, you have their best interests at heart and that you want to be able to provide them with a photograph that will make them happy and proud.

HIGH-END SENIOR STUDIOS
Senior portraits are usually done by the schools on picture day, but that is not the type of senior portraiture referred to here. Many studios have taken to offering high-end, very hip, upscale senior sittings that allow the kids to be photographed with their favorite things in their favorite locations. For instance, a senior's car, usually a treasured possession, is a prime prop included in these sessions.

Often senior sessions will involve the subject's friends and favorite haunts. Or, in the case of senior girls, they will want to be photographed in a fashion/glamour pose, wearing something pretty racy—like what they see on MTV. This is all part of the process of expressing their individuality and becoming an adult. Instead of resisting it, many smart photographers are now catering to it. (*Note:* With these types of sessions, it is important to have

FACING PAGE—Tim Kelly's posing techniques are unusual and effective. Tim's kids' portraits (younger and older) often show hands that are awkwardly or bashfully posed, but always they reveal character. And he likes to have his subjects leaning in or away, almost thrusting themselves into the frame. The effect provides great visual movement and a sense of visual dynamics in the portrait. Note here how he highlighted this young lady's perfectly oval face by outlining the face in "stray" hairs. The intensity of her eyes and her natural beauty make this a transcendent senior portrait.

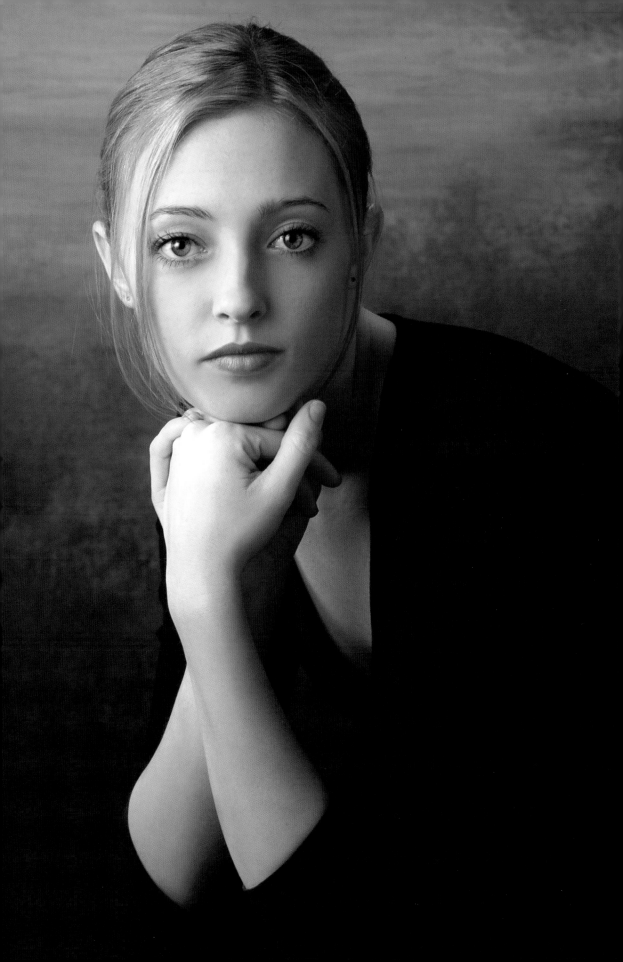

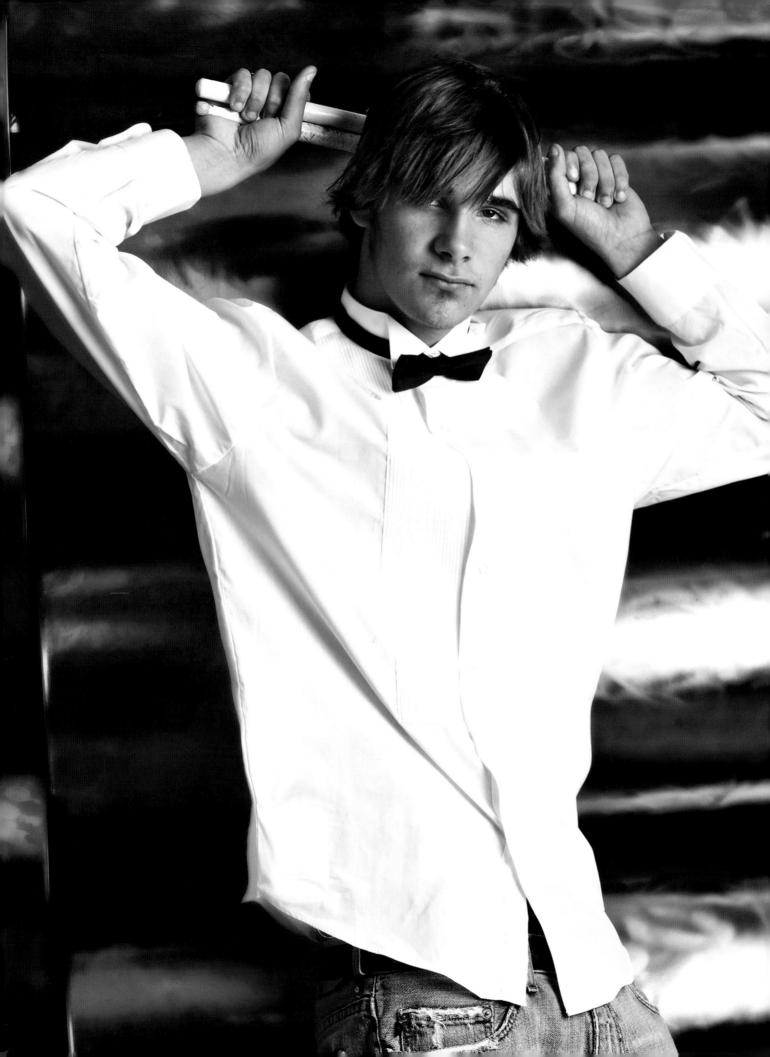

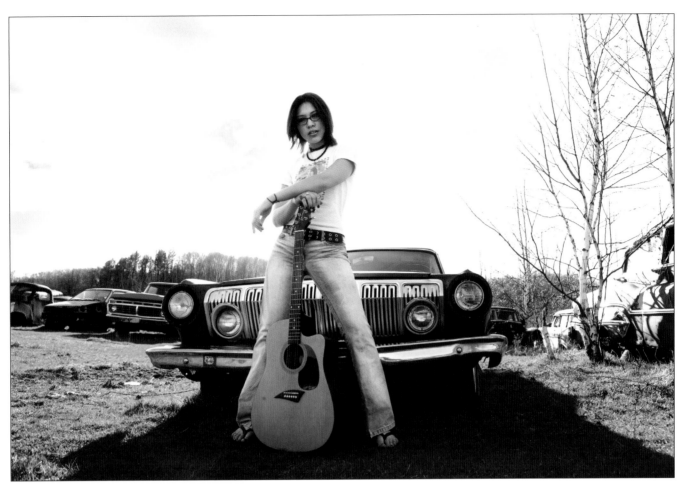

a pre-shoot meeting with one or both parents to determine what is expected.)

POSING

Adolescents and high-school seniors will react poorly to traditional posing, yet some structure is needed. The best way to proceed is to choose a natural pose.

Relaxed and Natural. With boys, find a pose that they feel natural in and work out of that pose. Find a comfortable seat, even if it's on the floor of the studio, and then refine the pose to make it a professional portrait. A good pose for teenage boys is to have them thrust their hands in their pockets with the thumbs out. It is a kind of "cool" pose in which they'll feel relaxed. Be sure to keep space between their arms and body. Another good pose for boys is to have them sit on the floor with one knee up and wrap their hands around the knee—a variation on the "tripod pose" described earlier for small children. It is a casual pose from which many variations can be achieved.

Girls, like women of all ages, want to be photographed at their best—looking slim and beautiful. Therefore, it is

FACING PAGE—Tim Schooler's seniors love his work and seem to really admire him as a person and a photographer. His website is loaded with unedited comments from seniors, many of whom call him "Mr. Tim." Mostly they thank him because the session was a "really a blast" and they had a great time.

ABOVE—Chris Nelson loves to take his senior subjects to an auto graveyard in a rural setting—and the kids he photographs seem to like it, too.

imperative to use poses that flatter their figures and make them look attractive.

Active. Seniors and teens like activity and bright colors in their portraits. They also like their music playing in the background as they pose, so ask them to bring along a few CDs when they come to have their portrait made. Work quickly to keep the energy level high.

Try to photograph several different settings with at least one outfit change. Show them the backgrounds and props that you have available and ask them to choose from among them. You should have a wide variety of backgrounds and props to choose from. You will be surprised at what they select.

FACING PAGE, TOP—Bruce Dorn, as a filmmaker, tends to think in the horizontal format, using the film frame cinematically. Here, he used an undiffused softbox remotely triggered by a Pocket Wizard to provide a sharp-angled main light, reminiscent of sunlight. The device, which Dorn created and offers for sale off his website (www.idcphotography.com), is called the Strobe Slipper. In this example, the undiffused softbox was held by an assistant at close range to provide a main light. The clouds are diffused and hazy as if this were a dream. The boy's hair and overall look is reminiscent of James Dean posters from the 1950s.

FACING PAGE, BOTTOM—In this image, Bruce Dorn incorporated a wild background of power and phone lines and has taken great care to have a line running through each of the twins' heads—as if they were part of the information transmitted across the lines. The image was lit with Dorn's Strobe Slipper, but this time the softbox was diffused and used very close to the twins so that the light was ultra-soft.

TOP LEFT—Bruce Dorn's Strobe Slipper is a self-contained softbox that uses a Pocket Wizard and Canon Speedlight mounted in a small 24-inch square Photoflex softbox. The device can also be configured to hold an external battery.

BOTTOM LEFT—Chris Nelson uses natural light and lets his teen subjects pose how they want to be seen. Here, we have a dancer on top of an ancient pickup.

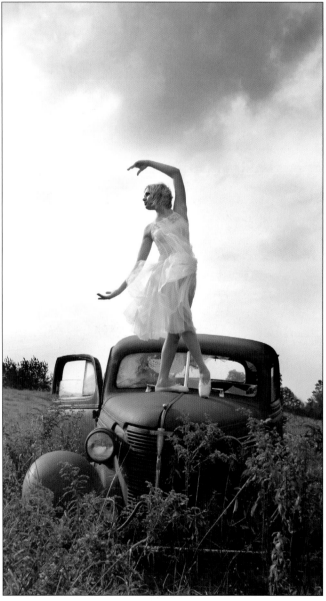

PSYCHOLOGY

Part of your job is to make your subjects feel good about themselves, which can take the form of reassurance or flattery, both of which should be doled out in a realistic way or they won't be believed. Like all kids, teens will react positively to your enthusiasm and positive energy as long as they feel it's genuine.

It is often said that one of the ingredients of a great portrait photographer is an ability to relate to other people. With teens, a genuine interest in them as people can go a long way. Ask them about their lives, their hobbies, their likes and dislikes, and try to get them to open up to you. Of course, this is not always easy. Some teens are introspective and moody and it will take all of your social skills to bring them out of their shells.

Part of being a good psychologist is watching the subject's mannerisms and expressions. You will get a chance to do that if you have a pre-session meeting, which is advisable. Take notes as to poses that the client may fall into naturally—both seated and standing. Get a feeling for how they carry themselves and their posture. You can then use this information in the photo session. Such insight makes them feel that you are paying attention to them as individuals.

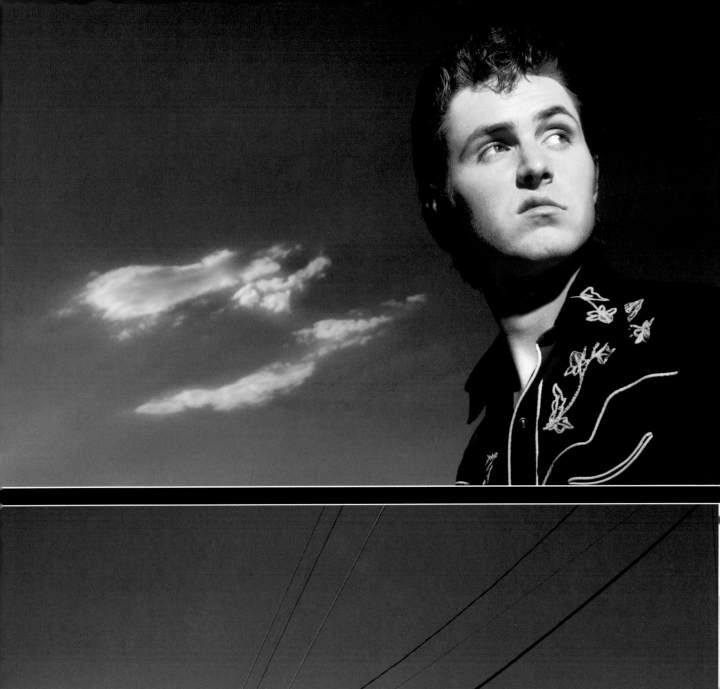

FACING PAGE—Tim Schooler has his seniors dress in exactly the clothes they want to. Most senior girls choose outfits that accentuate their figures and Tim's style of photography, with its punchy color and great posing, make for a very salable product. The words of thanks and praise for his photos from senior clients that appear on his website (www.timschooler.com) are amazing.

ABOVE—Photographers specializing in senior portraits have to have the youthful imagination to keep up with their clientele. This image is called *Closed Angry Minds*, and no doubt appeals to Craig's senior subject.

This is important, as one of the differences between big kids and little kids is that the older ones think of themselves as individuals. They will often have unique clothes or hair (or tattoos or piercings) that set them apart. Instead of reacting negatively to their uniqueness, react with appreciation. Also, keep in mind that seniors are at a transitional age. These clients often have boyfriends or girlfriends and are thinking about college and about leaving home—all of which can make life confusing. A portrait made at this stage of their lives is a valuable heirloom, because they will never look or act quite like this again.

You may also have to exercise a little less control over a senior setting. Teens want to feel that they have control, particularly over their own image. You should suggest possibilities and, above all, provide reassurance and reinforcement that they look great. Often, the best way to proceed is to tell your subject that you will be making a series of images just for Mom and Dad, and then you'll make some images just for them.

THE MANY FACES OF . . .
As with any good portrait sitting, the aim is to show the different sides of the subject's personality. Adults have all sorts of armor and subterfuge that prevent people from seeing their true natures. Teenagers aren't nearly that sophisticated—but, like adults, they are multifaceted. Try to show their fun side as well as their serious side. If they are active or athletic, arrange to photograph them in the clothes worn for their particular sport or activity. Clothing changes help trigger the different facets of personality, as do changes in location.

10. STORYTELLING BOOKS

A recent development in children's portraiture is the creation of the storytelling album, which is very similar to a bound wedding album. These albums contain a variety of images that may capture a special event in a child's life or, more broadly, a whole year of their life—with all their accomplishments and personality traits. Parents cherish these albums as reminders of a childhood that passes all too quickly.

PATTI ANDRE'S SIGNATURE STORYBOOKS

Patti Andre, owner of As Eye See It Photography in Rancho Santa Fe, CA, calls her children's album books "Signature Storybooks." Clients commission her books not only because they want to commemorate important events, but also because her books are works of art.

Patti and her husband, Tom, did months of research, tried different bindery shops and album companies, until they came up with the perfect treatment. Patti says. "Our books are very labor-intensive because we do absolutely *everything*—from the design and layout to printing the pages on our Epson 7600 inkjet printer." Then, they outsource the final gluing, binding, and specialized covers.

To start each project, Patti makes 2x3-inch proofs of just her favorite images for layout purposes and to begin a story line. Clients then receive a full working proof book of 2x3 prints. According to Patti, "Every page is built from scratch and customized, depending on the progression of the story. Having a close working relationship with clients allows me to find out what they like and who's most important to them from an event."

ABOVE AND PAGES 101–4—This is the album of Capri. Her mom found out she was pregnant when she was about to undergo breast augmentation surgery. The surgeon came in and said, "We can't operate on you, you're pregnant." And so begins the story of Capri. "I worked with Patti Andre on a storybook for my daughter, Capri Michael Nova—age twenty months," says Capri's Mom. "We decided that we would focus on Capri's first year of life, from conception, through pregnancy, to labor, and then her firsts, ending with her first birthday). Patti exceeded my every expectation with her beautiful creation. I almost cried the first time she presented me the book. Her mixture of text, images, and color could not have more perfectly embodied all of the feelings that my daughter and I shared for her first twelve months. I received a big book and a mini book (which I carry in my purse everywhere). I have decided to work with Patti every year on a book for Capri so that when she is eighteen, I can present her with all the books, walking her through all of the special moments she gave me and our family. For me, this is more than a storybook. It's a legacy that I can pass down from generation to generation."

MENS NOVA, KRISTIE 2068969 UCSD FETAL CENTER
12.25.09 03/26/04 TR
ENS NOVA, KRISTIE 206

PROFILE S MI 1.5 FACE

3.5C40H/2.5
OB
100%
34dB RS3
14.0cm 10fps
Z

THI

Pan
0:26:29

MENS NOVA, KRISTIE 2068969 UCSD FETAL CENTER
12.26.33 03/26/04 TR
NOVA, KRISTIE 2068969 UCSD FETAL CENTER
12.19.15 03/26/04 TR

GIRL!! MI 1.5 FOOT S MI 1.

3.5C40H/2.5
OB
100%
34dB RS3
14.0cm 10fps
Z

THI

3.5C40H/2.3
OB
100%
34dB RS3
14.0cm 18fps
Z

THI

Text
0:26:29

WHAT IS A NOVA?

A NOVA IS A STRONG, RAPID INCREASE IN THE
BRIGHTNESS OF A STAR. THE WORD COMES
FROM LATIN FOR "NEW STAR," BECAUSE
OFTEN A STAR PREVIOUSLY TOO DIM TO BE
SEEN WITH THE NAKED EYE CAN BECOME
THE BRIGHTEST OBJECT IN THE SKY
WHEN IT BECOMES A NOVA.

WHAT IS A SUPERNOVA?

CAPRI MICHAEL NOVA

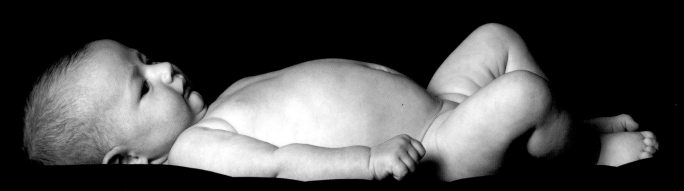

MASS: 7 LBS 2 OUNCES
DIAMETER: 23 INCHES
ORIGINATION: 8.27.04
CONSTELLATION: VIRGO
FAMILY ORBITALS: MICHAEL, KRISTIE AND EVAN

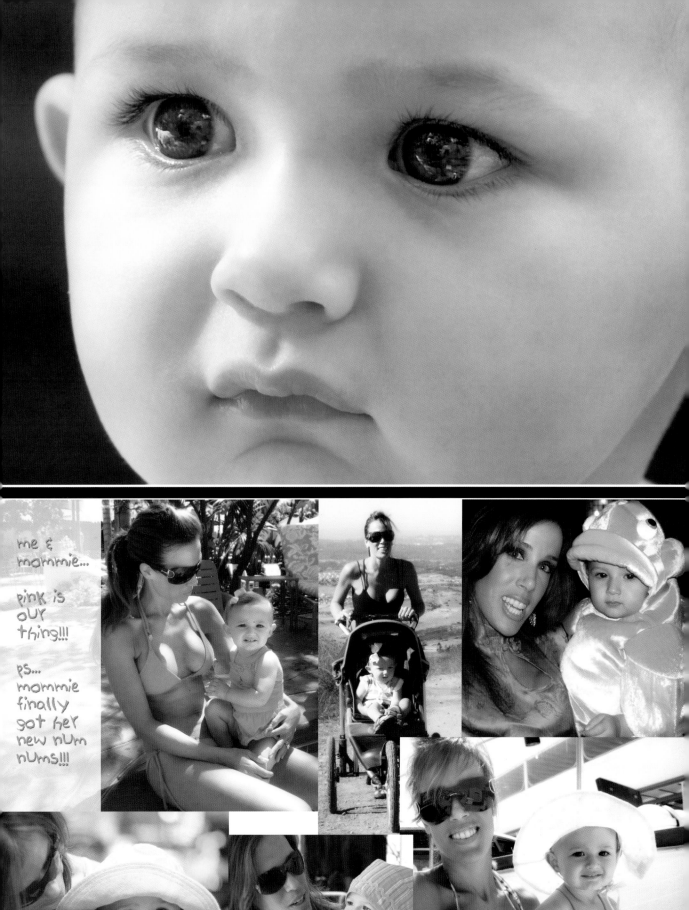

me & mommie...

pink is our thing!!!

ps... mommie finally got her new num nums!!!

My mommie always likes me to wear BIG bows.

the end.

800.862.0723

© 2005 As Eye See It.
www.aseyeseeit.com

Patti shoots in RAW format because it is like a negative. She can go back to the unaltered original anytime, which is not the case when shooting JPEGs. "Dodging and burning in the darkroom," she says, "did not affect the original negative. RAW works the same way." "The only downside of shooting RAW is the huge files," Tom adds.

Patti loves kids and childhood. As she says on her web site, "We experience it every day, this thing called life. Intertwined with life is this thing called time, and somehow there is never enough of it. No matter how much more we need, it just keeps flying by. We love our children—the sweet smell of their bodies, the silky softness of their skin, and the innocence of their hearts. They are babies one day, and suddenly we turn around and they are five. We watch them play, read their favorite story a thousand times, fix their toys, kiss their cheeks, hold their hands, dry their tears, and give countless snuggles. Each of those minutes is precious. The day comes too soon when they say, 'I can put myself to bed, Mom.'"

Patti says of her albums, "Our books not only tell a story of a moment in time, they are unique and customized in every way. Each book is personalized from notes or letters, artwork, or bits and pieces of written words—inspirational words, memories, and maybe some old photographs from Mom and Dad. Each storybook is well thought out and storyboarded. It is a very personal reflection, with countless hours tirelessly spent enhancing images and placing them just so." The blending of Patti's photography with Tom's expertise in the entertainment printing industry has enhanced their storybooks, so the control over the entire process stays with them.

ABOVE AND NEXT PAGE—Each of Patti Andre's covers for her storybook albums is unique and reflects the inner story in the album. Countless hours are spent on each album, which is a one-of-a-kind treatment.

VANESSA CAUGHT THE RED FISH & GOT THE BIGGEST PRIZE!

RCS

GRAND WHEEL

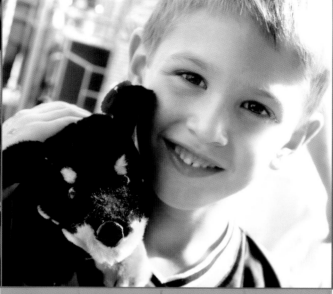

007065 ONE TICKET SAN DIEGO COUNTY FAIR GOOD 2005 ONLY DILLINGHAM TICKET CO., L.A.

007065 ONE TICKET SAN DIEGO COUNTY FAIR GOOD 2005 ONLY DILLINGHAM TICKET CO., L.A.

007065 ONE TICKET SAN DIEGO COUNTY FAIR GOOD 2005 ONLY DILLINGHAM TICKET CO., L.A.

007065 ONE TICKET SAN DIEGO COUNTY FAIR GOOD 2005 ONLY DILLINGHAM TICKET CO., L.A.

007065 ONE TICKET SAN DIEGO COUNTY FAIR GOOD 2005 ONLY DILLINGHAM TICKET CO., L.A.

007065 ONE TICKET SAN DIEGO COUNTY FAIR

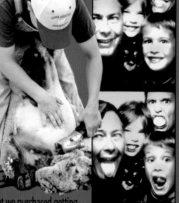

FAVORITES All the rides...especially being at the Top of the Ferris Wheel! The Crazy Mouse roller coaster. The food...in particular the fried zucchini! Tristen: Hot Dog on a Stick! Vanessa: Cotton Candy!

BEST Being with family! Watching the kids faces light up! The hypnotist! The pig races! Snake guy! $20 dollar ride all day. Costume dancers. Shooting the star out! and curly slides.

WORST Our favorite hammock that we purchased getting left out in the rain and rotting out. Running out of tickets. Ross missing for 30 seconds! Almost throwing up from the spinning balloon ride. UGH!

SCARIEST Vanessa- the Zombie ride-NO WAY! The cost of the 4 days spent at the fair! $$$$$ The possibility of losing a child in the crowds.

FRIENDS/FAMILY Sarah, Parker & Ross! Grandma & Grandpa!!! Wonder who will join us next year???

TRISTEN & VANESSA,

CAN'T WAIT TO DO THE FAIR AGAIN NEXT YEAR!!! WE LOVE YOU! XOXO

MOM & DAD, 2005

ABOVE AND NEXT TWO PAGES—Patti does a lot of albums that celebrate a year of a child's life—in this case, six-year old Parker. The mom's inscription in the front of the album tells you all you need to know about why parents treasure these albums.

FAVORITE THINGS...

I LOVE ...

THE COLOR BLUE

YUMMY ICE CREAM

MEAT AND SALAD

SNOWBOARDING, SWIMMING, GOLF AND BIKE RIDING (TWO WHEELS!)

SOCCER, T-BALL AND KARATE (PURPLE BELT)

COOL MOVIES: SPIDER MAN II, CAT IN THE HAT, SHREK II, AND SPY KIDS

WEEKEND CARTOONS: BUGS BUNNY, POPEYE, TOM & JERRY

TRUE FACT ANIMAL BOOKS

MY DOGS, BEN AND TOSHA

DRAWING PICTURES FOR MY SISTER ASHLEY

GOLF WITH DAD

READING AND SNUGGLING WITH MOM

MY NANNY ROSE, AND MY TEACHER, MRS. BERNARD

MY BUDDIES: JULIA, HANNAH, ANDRE, TAYLOR AND MAX

SPENDING TIME IN THE GARDEN AND PLAYING HIDE & SEEK WITH ROSS

TRAVELING TO ASPEN, EUROPE, SANTA BARBARA AND AUNT ERIN'S

BEING AN OLYMPIC RUNNER, SWIMMER AND DIVER!

PARKER AGE 6

4'10" • 43-1/2 LBS

PAGE DESIGN AND LAYOUT

While design is a critical component of any well composed photograph, good design is even more essential when laying out a book featuring photos, text, and other visual elements.

Left- and Right-Hand Pages. Look at any well-designed book or magazine and study the differences between the images on left- and right-hand pages. They have one thing in common: they lead the eye toward the center of the book, commonly referred to as the "gutter."

These photos use the same design elements photographers use in creating effective images: lead-in lines, curves, shapes, and patterns. If a line or pattern forms a C shape, it is an ideal left-hand page, since it draws the eye into the gutter and across to the right-hand page. If an image is a backward C shape, it is an ideal right-hand page, leading the eye back toward the gutter and the left-hand page. Familiar shapes like hooks or loops, triangles, and circles are used in the same manner to guide the eye into the center of the two-page spread and across to the right-hand page.

There is infinite variety in laying out images, text and graphic elements to create this left and right orientation. For example, an image or a series of photos can produce a strong diagonal line that leads from the lower left-hand corner of the left page to the gutter. That pattern can be duplicated on the right-hand page, or it can be contrasted for variety. The effect is visual motion.

Even greater visual interest can be attained when a line or shape, which is started on the left-hand page, continues through the gutter, into the right-hand page, and back again to the left-hand page. This is the height of visual movement in page design.

Variety. When you lay out your book images, think in terms of variety of size. Some images should be small, some big. Some should extend across the spread. No matter how good the individual photographs are, the effect of a book in which all the images are the same size is static.

Variety can also be introduced by combining black & white and color—even on the same pages. Try combining detail shots and wide-angle panoramas. How about a series of close-up portraits of the child on the left-hand page contrasted with a wide-angle shot of the child's favorite pet, toy, or even his bedroom? Do not settle for the one-picture-per-page theory. It's static and boring.

Left to Right. Remember a simple concept: in Western civilization we read from left to right. We start on the left page and finish on the right. Good page design leads the eye from left to right and it does so differently on every page.

SEQUENCES

If story albums are similar to a novel, then a sequence is more like a short story. Sequences are appropriate when a single photograph just doesn't convey the many wonderful things that happened in a photo session, or when you want to portray the different sides of an event or special day, such as a first birthday party.

Often, sequences are shot rapid-fire with motor drives, documenting some action. They can also be a series of varied expressions taken from the same angle, depicting the many sides and moods of the child. These images are often displayed on mount boards or in folders and should follow the principles of good page design and layout; you should be able to trace line, form, direction, movement, tension and balance within the assembled images.

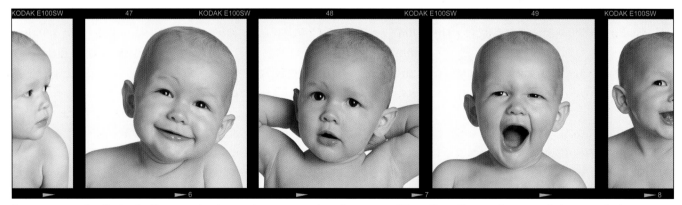

Sequences are fun for both albums and as interesting presentations for parents. Here, Stacy Bratton has recorded some priceless expressions as a sequence of this delightful one-year-old.

Angle of incidence. The angle of incidence is the original axis on which light travels. The angle of reflection is the secondary angle light takes when reflected off of some surface. The angle of incidence is equal to the angle of reflection.

Balance. A state of visual symmetry among elements in a photograph.

Barebulb flash. A portable flash unit with a vertical flash tube that fires the flash illumination 360 degrees.

Barn doors. Black, metal folding doors that attach to a light's reflector; used to control the width of the beam.

Bleed. A page in a book or album in which the photograph extends to the edges of the page.

Bounce flash. Bouncing the light of a studio or portable flash off a surface such as a ceiling or wall to produce indirect, shadowless lighting.

Box light. A diffused light source housed in a box-shaped reflector. The bottom of the box is translucent material; the side pieces of the box are opaque, but they are coated with a reflective material such as foil on the inside to optimize light output.

Broad lighting. One of two basic types of portrait lighting in which the main light illuminates the side of the subject's face turned toward the camera.

Burst Rate. The number of frames per second (fps) a digital camera can record images and the number of frames per exposure sequence a camera can record. Typical burst rates range from 2.5fps up to six shots, all the way up to 8fps up to forty shots.

Butterfly lighting. One of the basic portrait lighting patterns, characterized by a high-key light placed directly in line with the line of the subject's nose. This lighting produces a butterfly-like shadow under the nose. Also called paramount lighting.

Card reader. A device used to connect a memory card or microdrive to a computer. Card readers are used to download image files from a capture and/or storage device to your computer workstation.

Catchlight. The specular highlights that appear in the iris or pupil of the subject's eyes reflected from the portrait lights.

CCD (Charge-Coupled Device). A type of image sensor that separates the spectrum of colors into red, green and blue for digital processing by the camera. A CCD captures only black & white images. The image is passed through red, green and blue filters in order to capture color.

CMOS (Complementary Metal Oxide Semiconductor). A type of semiconductor that has been, until the Canon EOS D30, widely unavailable for digital cameras. CMOS chips are less energy consuming than other chips that utilize simply one type of transistor.

Color management. A system of software-based checks and balances that ensures consistent color, through a variety of capture, display, editing, and output device profiles.

Color space. An environment referring to the range of colors that a particular device is able to produce.

Color temperature. The degrees Kelvin of a light source. Also refers to a film's sensitivity. Color films are balanced for 5500°K (daylight), or 3200°K (tungsten), or 3400°K (photoflood).

Cross-lighting. Lighting that comes from the side of the subject, skimming facial surfaces to reveal the maximum texture in the skin. Also called sidelighting.

Cross shadows. Shadows created by lighting with two light sources from either side of the camera. These should be eliminated to restore the "one-light" look.

Depth of field. The distance that is sharp beyond and in front of the focus point at a given f-stop.

Depth of focus. The amount of sharpness that extends in front of and behind the focus point. Some lens's depth of focus extends 50 percent in front of and 50 percent behind the focus point. Other lenses may vary.

Diffusion flat. A portable, translucent diffuser that can be positioned in a window frame or near the subject to diffuse the light striking him or her.

Dragging the shutter. Using a shutter speed slower than the X-sync speed in order to capture the ambient light in a scene.

Feathering. Misdirecting the light deliberately so that the edge of the beam of light illuminates the subject.

Fill card. A white or silver-foil-covered card used to reflect light back into the shadow areas of the subject.

Fill light. Secondary light source used to fill in the shadows created by the main light.

Flash fill. Flash technique that uses electronic flash to fill in the shadows created by the main light source.

Flash main. Flash technique in which the flash becomes the main light source and the ambient light in the scene fills the shadows created by the flash.

Flashmeter. A handheld incident meter that measures both the ambient light of a scene and when connected to the main flash, will read flash only or a combination of flash and ambient light. They are invaluable for determining outdoor flash exposures and lighting ratios.

Foreshortening. A distortion of normal perspective caused by close proximity of the camera/lens to the subject. Foreshortening exaggerates subject features. noses appear elongated, chins jut out and the backs of heads may appear smaller than normal.

45-degree lighting. Portrait lighting pattern characterized by a triangular highlight on the shadow side of the face. Also called Rembrandt lighting.

Full-length portrait. A pose that includes the full figure of the model. Full-length portraits can show the subject standing, seated or reclining.

Gobo. Light-blocking card that is supported on a stand or boom and positioned between the light source and subject to selectively block light from portions of the scene.

Gutter. The inside center of a book or album.

Head-and-shoulder axis. Imaginary lines running through shoulders (shoulder axis) and down the ridge of the nose (head axis). The head-and-shoulder axis should never be perpendicular to the line of the lens axis.

High-key lighting. Type of lighting characterized by low lighting ratio and a predominance of light tones.

Highlight. An area of the scene on which direct light is falling, making it brighter than areas not receiving direct light; i.e., shadows.

Highlight brilliance. The specularity of highlights on the skin. A negative with good highlight brilliance shows specular highlights (paper base white) within a major highlight area. Achieved through good lighting and exposure techniques.

Histogram. A graph associated with a single image file that indicates the number of pixels that exist for each brightness level. The range of the histogram represents values from 0 to 255, reading left to right, with 0 indicating "absolute" black and 255 indicating "absolute" white.

Hot spots. A highlight area of the negative that is overexposed and is without detail. Sometimes these areas are etched down to a printable density.

ICC Profile. File that contains device-specific information that describes how the device behaves towards color density and color gamut. Since all devices communicate differently, as far as color is concerned, profiles enable the color management system to convert device-dependent colors into or out of each specific color space based on the profile for each component in the workflow. ICC profiles can utilize a device-independent color space to act as a translator between two or more different devices.

Incident light meter. A handheld light meter that measures the amount of light falling on its light-sensitive cell.

JPEG (Joint Photographic Experts Group). An image file format with various compression levels. The higher the compression rates, the lower the image quality, when the file is expanded (restored). Although there is a form of JPEG that employs lossless compression, the most commonly used forms of JPEG employ lossy compression algorithms, which discard varying amounts of the original image data in order to reduce file storage size.

Main light. The main light in portraiture used to establish the lighting pattern and define the facial features of the subject.

Kicker. A backlight (a light coming from behind the subject) that highlights the hair, side of the face or contour of the body.

Lead-in line. In compositions, a pleasing line in the scene that leads the viewer's eye toward the main subject.

Lens circle. The circle of coverage; the area of focused light rays falling on the film plane or digital imaging chip.

Levels. In Photoshop, Levels allows you to correct the tonal range and color balance of an image. In the Levels window, Input refers to the original intensity values of the pixels in an image and Output refers to the revised color values based on your adjustments.

Lighting ratio. The difference in intensity between the highlight side of the face and the shadow side of the face. A 3:1 ratio implies that the highlight side is three times brighter than the shadow side of the face.

Loop lighting. A portrait lighting pattern characterized by a loop-like shadow on the shadow side of the subject's face. Differs from paramount or butterfly lighting because the main light is slightly lower and farther to the side of the subject.

Lossless format. Describes file formats without image compression. A lossless format, means that the file can be saved again and again without degradation.

Lossy format. Describes JPEG and some TIFF formats where file compression occurs. Lossy files suffer from degradation by repeated opening and closing .

Low-key lighting. Type of lighting characterized by a high lighting ratio and strong scene contrast as well as a predominance of dark tones.

Main light. Synonymous with main light.

Matte box. A front-lens accessory with retractable bellows that holds filters, masks and vignettes for modifying the image.

Metadata. Text "tags" that accompany the digital files. Data often includes date, time, camera settings, caption info, copyright symbol, and even GPS information. Metadata is accessible in Photoshop by going to File>File Info>EXIF data.

Microdrive. Storage medium for portable electronic devices using the CF Type II industry standard. Current Microdrive capacities range from 340MB to 1GB of storage. The benefit of a Microdrive is high storage capacity at low cost. The downside is the susceptibility to shock. bumping or dropping a Microdrive has been known to lead to data loss.

Modeling light. A secondary light mounted in the center of a studio flash head that gives a close approximation of the lighting that the flash tube will produce. Usually high intensity, low-heat output quartz bulbs.

Overlighting. When the main light is either too close to the subject, or too intense and oversaturates the skin with light, making it impossible to record detail in highlighted areas. Best corrected by feathering the light or moving it back.

Noise. Noise is a condition, not unlike excessive grain, that happens when stray electronic information affects the image sensor sites. It is made worse by heat and long exposures. Noise shows up more in dark areas making evening and night photography problematic with digital capture.

Optimum lens aperture. The aperture on a lens that produces the sharpest image. It is usually two stops down from the widest aperture. If the lens is an f/2.8 lens, for example, the optimum aperture would be f/5.6.

Parabolic reflector. Oval-shaped dish that houses a light and directs its beam outward in an even, controlled manner.

Paramount lighting. One of the basic portrait lighting patterns, characterized by a high main light placed directly in line with the line of the subject's nose. This lighting produces a butterfly-like shadow under the nose. Also called butterfly lighting.

Perspective. The appearance of objects in a scene as determined by their relative distance and position.

PSD. Photoshop file format (PSD) is the default file format and the only format that supports all Photoshop features. The PSD format saves all image layers created within the file.

RAW. A file format, which uses lossless compression algorithms to record picture data as is from the sensor, without applying any in-camera corrections. In order to use images recorded in the RAW format, files must first be processed by compatible software. RAW processing includes the option to adjust exposure, white balance and the color of the image, all the while leaving the original RAW picture data unchanged.

Reflected light meter. Measures the amount of light reflected from a surface or scene. All in-camera meters are of the reflected type.

Reflector. (1) Same as fill card. (2) A housing on a light that reflects the light outward in a controlled beam.

Rembrandt lighting. Same as 45-degree lighting.

Rim lighting. Portrait lighting pattern where the main light is behind the subject and illuminates the edge of the subject. Most often used with profile poses.

Rule of thirds. Format for composition that divides the image area into thirds, horizontally and vertically. The intersection of two lines is a dynamic point where the subject should be placed for the most visual impact.

Scrim. A panel used to diffuse sunlight. Scrims can be mounted in panels and set in windows, used on stands or can be suspended in front of a light source to diffuse the light.

Seven-eighths view. Facial pose that shows approximately seven-eighths of the face. Almost a full-face view as seen from the camera.

Shadow. An area of the scene on which no direct light is falling, making it darker than areas receiving direct light, i.e., highlights.

Sharpening. In Photoshop, filters that increase apparent sharpness by increasing the contrast of adjacent pixels within an image.

Short lighting. One of two basic types of portrait lighting in which the main light illuminates the side of the face turned away from the camera.

Slave. A remote triggering device used to fire auxiliary flash units. These may be optical or radio-controlled.

Softbox. Same as a box light. Can contain one or more light heads and single or double-diffused scrims.

Specular highlights. Sharp, dense image points on the negative. Specular highlights are very small and usually appear on pores in the skin.

Split lighting. Type of portrait lighting that splits the face into two distinct areas: shadow side and highlight side. The main light is placed far to the side of the subject and slightly higher than the subject's head height.

Spotmeter. A handheld reflected light meter that measures a narrow angle of view, usually 1 to 4 degrees.

sRGB. Color matching standard jointly developed by Microsoft and Hewlett-Packard. Cameras, monitors, applications, and printers that comply with this standard are able to reproduce colors the same way. Also known as a color space designated for digital cameras.

Straight flash. The light of an on-camera flash unit that is used without diffusion.

Subtractive fill. Lighting technique that uses a black card to subtract light from a subject area in order to create a better defined lighting ratio. Also refers to the placement of a black card over the subject in outdoor portraiture to make the light more frontal and less overhead.

TTL-balanced fill flash. Flash exposure systems that read the flash exposure through the camera lens and adjust flash output to compensate for flash and ambient light exposures, producing a balanced exposure.

Tension. A state of visual imbalance within a photo.

Three-quarter-length pose. Pose that includes all but the lower portion of the subject's anatomy. Can be from above the knees and up, or below the knees and up.

Three-quarter view. Facial pose that allows the camera to see three-quarters of the facial area. Subject's face usually turned 45 degrees away from the lens so that the far ear disappears from camera view.

TIFF (Tagged Image File Format). File format commonly used for image files. There are several kinds of TIFF files. TIFF files are lossless, meaning that no matter how many times they are opened and closed, the data remains the same, unlike JPEG files, which are designated as lossy files, meaning that data is lost each time the files are opened and closed.

Umbrella lighting. Type of soft, casual lighting that uses one or more photographic umbrellas to diffuse the light source(s).

Unsharp Mask. A sharpening tool in Adobe Photoshop that is usually the last step in preparing an image for printing.

USB/USB 2.0 (Universal Serial Bus). An external bus standard that supports data transfer rates of 12MB per second. USB is particularly well suited for high-speed downloading of images from your digital camera straight to your computer. USB 2.0 transfers data at a much greater rate than USB, with a 480 MB per second in a dedicated USB 2.0 port.

Vanishing Point. A point at which receding parallel lines seem to meet when represented in linear perspective or a point at which something disappears or ceases to exist.

Vignette. A semicircular, soft-edged border around the main subject. Vignettes can be either light or dark in tone and can be included at the time of shooting, or added later in printing.

Watt-seconds. Numerical system used to rate the power output of electronic flash units. Primarily used to rate studio strobe systems.

White balance. The camera's ability to correct color and tint when shooting under different lighting conditions including daylight, indoor and fluorescent lighting.

Working color space. Predefined color management settings specifying the color profiles to be associated with the RGB, CMYK, and grayscale color modes. The settings also specify the color profile for spot colors in a document. Central to the color management workflow, these profiles are known as working spaces. The working spaces specified by predefined settings represent the color profiles that will produce the best color fidelity for several common output conditions.

Wraparound lighting. Soft type of light, produced by umbrellas, that wraps around subject producing a low lighting ratio and open, well-illuminated highlight areas.

X-sync. The shutter speed at which focal-plane shutters synchronize with electronic flash.

Zebra. A term used to describe reflectors or umbrellas having alternating reflective materials such as silver and white cloth.

THE PHOTOGRAPHERS

I want to thank all of the talented photographers who appear in this book, not only for the use of their award-winning images, but also for their exceptional insight into children's portraiture.

Patti Andre. Patti, whose studio is called As Eye See It, holds a BFA from Art Center College of Design in Pasadena, where she graduated with honors. Her work has appeared in many magazines and her clients include Scripps Hospital, Masar/Johnston, Ketchum Advertising, Children's Hospital, Saint John's Hospital, Amgen, United Way, USC, and many others. Patti's work has received numerous awards from WPPI.

Janet Baker Richardson. From a successful career as a producer of television commercials, Janet was drawn towards photographing children by the simplicity and honesty of the profession. Not having the funds, at the time, for studio lights, she mastered the use of outdoor and window light and has subsequently created a meaningful niche in the world of children's portraiture. Janet lives with her family in Los Angeles where she runs a home-based business.

Fernando Basurto. Fernando Basurto is an accomplished wedding photographer who does business in historical Whittier, CA. Specializing in wedding photojournalism Fernando has created some of the most powerful and passionate wedding images of today. Fernando is a member of WPPI and has judged their print competitions. He also holds the APM and AOPA degrees. You can see more of his work by visiting his site: www.elegant photographer.com.

Marcus Bell. Marcus Bell's creative vision, fluid natural style and sensitivity have made him one of Australia's most revered photographers. It's this talent combined with his natural ability to make people feel at ease in front of the lens that attracts so many of his clients. His work has been published in numerous magazines in Australia and overseas, including *Black White, Capture,* and *Portfolio Bride.*

David Bentley. David Bentley owns Bentley Studio, Ltd. in Frontenac, MO, with his wife Susan, also a master photographer. With a background in engineering, David calls upon a systematic as well as creative approach to each of his assignments. His thirty years of experience and numerous awards speak to the success of the system.

Don Blair. For over fifty years, Don Blair was synonymous with fine portraiture, craftsmanship, and extraordinary contributions to the industry. Don Blair was a master craftsman and a gifted and caring educator—hailed as a leader in this field. In professional circles, he was among the most respected of all portrait photographers, and affectionately known to many as "Big Daddy."

Stacy Dail Bratton. Stacy Bratton is a commercial and portrait photographer, book author, and owner of SD/SK Studio in downtown Dallas, TX. She is an accomplished children's' and family photographer, having shot more than 2500 baby portraits over the years. She is a graduate of Art Center College of Design in Pasadena, California and the author of *Baby Life* (Taylor Trade Publishing), a book featuring her black & white children's photographs.

Drake Busath (Master Photographer, Craftsman). Drake Busath, owner of Busath Photographers, is a second-generation professional photographer. He has spoken all over the world and has been featured in a wide variety of professional magazines. He operates a successful wedding and portrait studio, as well as a successful photography workshop in Italy.

Anthony Cava (BA, MPA, APPO). With his brother Frank, Anthony Cava owns and operates Photolux Studio in Ottawa, ON. Ten years ago, Anthony joined WPPI and the Professional Photographers of Canada, and was the youngest Master of Photographic Arts in Canada. He won WPPI's Grand Award with the first print he ever entered in competition.

Bruce Dorn and Maura Dutra. These award-winning digital imagemakers learned their craft in Hollywood, New York, and Paris. Maura has twenty years' experience as an art director and visual effects producer, and Bruce capped a youthful career in fashion and advertising photography with a twenty-year tenure in the very exclusive Director's Guild of America. They have earned a plethora of industry awards for excellence in image-making, and now teach worldwide.

Fuzzy and Shirley Duenkel. Fuzzy has been honored with numerous awards, including four Fuji Masterpiece Awards. In 1996 and 1997, he was named Photographer of the Year for the Southeastern Wisconsin PPA. Fuzzy has had fifteen prints selected for National Traveling Loan Collection, two for Disney's Epcot Center, one for Photokina in Germany, and one for the International Hall of Fame and Museum in Oklahoma.

Jim Fender. Jim Fender is part of Fender Donisch Photography in Naperville, IL. Fender has won numerous awards including many local honors, Fuji Masterpiece awards, and Kodak Gallery Awards. He also has several prints on display at Epcot Center in Disney World as well as in the PPA Traveling Loan collection. His studio has won the Top Wedding Album for the state of Illinois several times.

Deborah Lynn Ferro. A professional photographer since 1996, Deborah Lynn calls upon her background as a watercolor artist. She has studied with master photographers all over the world, including, Michael Taylor, Helen Yancy, Bobbi Lane, Monte Zucker, and Tim Kelly. In addition to being a fine photographer, she is also an accomplished digital artist.

Frank A. Frost, Jr. (PPA Certified, M.Photog.,Cr., APM, AOPA, AEPA, AHPA). Frank Frost has been creating his classic portraiture in Albuquerque, NM, for almost twenty years. Along the way, he has earned numerous awards from WPPI and PPA. His photographic ability stems from an instinctive flair for posing, composition, and lighting.

Jennifer George Walker. Jennifer George Walker runs her studio out of her home in the Del Mar, CA, an affluent neighborhood that is close to the beach and a variety of beautiful shooting locations. She has won the California Photographer of the Year and received the People's Choice Award 2001 at the Professional Photographers of California convention. In 2003, Jennifer was the Premiere category Grand Award winner. For moire, visit www.jwalkerphotography.com.

Jeff and Kathleen Hawkins. Jeff and Kathleen operate a fully high-end studio in Orlando, FL. Jeff Hawkins has been a professional photographer for over twenty years. Kathleen Hawkins holds a Masters in Business Administration and served as past president of the Wedding Professionals of Central Florida (WPCF) and past affiliate vice president for the National Association of Catering Executives (NACE). As a team, they have authored numerous instructional books for photographers.

Elizabeth Homan. Elizabeth Homan owns and operates Artistic Images, where she is assisted by her husband, Trey, and her parents, Penny and Sterling. Elizabeth holds a BA from Texas Christian University and was the decorated as the youngest Master Photographer in Texas in 1998. She holds many awards, including ten Fujifilm Masterpiece Awards, Best Wedding Album in the Southwest Region (six years), and two perfect scores of 100 in print competition.

Judy Host. Judy Host has won numerous awards for her photography and been featured in a number of publications for her outstanding environmental portraiture. The PPA from whom she has received a Masters and a Craftsman degree has selected her work for National Exhibition. She has also received three Kodak Gallery Awards. Many of her images have been exhibited at Epcot Center and are part of a traveling loan collection.

Kevin Jairaj. Kevin Jairaj is an award-winning wedding and portrait photographer whose creative eye has earned him a stellar reputation in the Dallas/Fort Worth, TX, area. He is formerly a fashion photographer who uses

skills learned in that discipline when shooting his weddings and portraits. His web site is www.kjimages.com.

Tim Kelly (M.Photog.). Tim Kelly is an award-winning photographer and the owner of an highly-awarded color lab. Since 1988, he has developed educational programs and delivered them to professional portrait photographers worldwide. Tim was named Florida's Portrait Photographer of the Year in 2001 and has earned numerous Kodak Awards of Excellence and Gallery Awards. Several of his images have been featured in the PPA Loan Collection. His studio/gallery in Lake Mary, FL, is devoted to fine art portraiture and hand-crafted signature work.

Craig Kienast. With imagination and a keen sense of marketing, Craig was the originator of Fantasia Art Prints, a wild form of imagery using Photoshop and Painter techniques combined with elegant lighting. Working in the small market town of Clear Lake, IO, Kienast ordinarily gets more than double the fees of his nearest competitor. Samples of Craig's work as well as his teaching materials can be seen on his web site www.photock.com.

Frances Litman. Frances Litman is an internationally known, award-winning photographer who resides in Victoria, BC. She has been featured by Kodak Canada in national publications and has had her images published in numerous books, on magazine covers, and in Fujifilm advertising campaigns. She holds Craftsman and Masters degrees from PPA of Canada and has been awarded the prestigious Kodak Gallery Award.

Kersti Malvre. Award-winning artist, Kersti Malvre of Los Altos, CA, is known for her unique, sensitive approach to portraiture. She photographs babies, children, family groups, and pets. Her extraordinary artistic vision merges black & white photography with oil painting. Kersti's delicate, yet rich use of color and her attention to detail gives her work a timeless quality.

Chris Nelson. Chris Nelson has been fascinated with photography since the age of ten. After graduating from the University of Wisconsin in 1985 with a degree in English and Journalism, he worked for six years as a press photographer and reporter for the *Milwaukee Sentinel*. In 1991, he opened a portrait studio where he concentrates on lifestyle portraits of kids, families, and seniors—all with a photojournalistic edge.

Suzette Nesire. Suzette Nesire is a highly regarded children's portrait photographer from Melbourne Australia. Her portraits provide an intimate look into a child's world and are proving to be a huge success with all her clients. Her website offers some excellent information about children and photographing them. Visit www.suzette.com.au.

Fran Reisner. Fran Reisner is an award-winning photographer from Frisco, TX. She is a Brooks Institute graduate and has twice been named Dallas Photographer of the Year. She is a past president of Dallas Professional Photographers Association and runs a highly successful business from the studio she designed and built on her residential property.

Tim Schooler. Tim Schooler Photography is an award-winning studio specializing in high school senior photography with a cutting edge. Tim's work has been published internationally in magazines and books. His studio is located in Lafayette, LA. Visit his website: www.timschooler.com.

Brian and Judith Shindle. Brian and Judith Shindle own and operate Creative Moments in Westerville, OH. This studio is home to three enterprises under one umbrella: a working photography studio, an art gallery, and a full-blown event-planning business. Brian's work has received numerous awards from WPPI in international competition.

Vicki and Jed Taufer. Vicki and Jed Taufer are the owners of V Gallery, a prestigious portrait studio in Morton, IL. Vicki has studied photography in Utah, Colorado, and Pennsylvania and has received national recognition for her portraits. She is also an award winner in WPPI print competitions. Jed is the head of the imaging department at V Gallery. Visit their impressive website at www.vgallery.net

Deanna Urs. Deanna Urs lives in Parker, CO, where she has turned her love for the camera into a portrait business and developed and national and international following. Deanna uses natural light and prefers subtle expressions, producing soulful portraits that will be viewed art and become heirlooms. Visit Deanna's website at www.deannaursphotography.com

INDEX

Also by Bill Hurter . . .

THE BEST OF CHILDREN'S PORTRAIT PHOTOGRAPHY

Bill Hurter draws upon the experience and work of top professional photographers, uncovering the creative and technical skills they use to create their magical portraits of these young subejcts. $29.95 list, 8½x11, 128p, 150 color photos, order no. 1752.

THE BEST OF PHOTOGRAPHIC LIGHTING

Top professional photographers reveal the secrets behind their successful strategies for studio, location, and outdoor lighting. Packed with tips for portraits, still lifes, and more. $34.95 list, 8½x11, 128p, 150 color photos, index, order no. 1808.

THE BEST OF FAMILY PORTRAIT PHOTOGRAPHY

Dozens of acclaimed photographers reveal the secrets behind their most successful family portraits. Packed with award-winning images and helpful techniques. $34.95 list, 8½x11, 128p, 150 color photos, index, order no. 1812.

PORTRAIT PHOTOGRAPHER'S HANDBOOK, 2nd Ed.

Bill Hurter has compiled a guide to portraiture that easily leads the reader through all phases of portrait photography. This book will be an asset to experienced photographers and beginners alike. $29.95 list, 8½x11, 128p, 175 color photos, order no. 1708.

RANGEFINDER'S PROFESSIONAL PHOTOGRAPHY

Editor Bill Hurter shares over one hundred "recipes" from *Rangefinder's* popular cookbook series, showing you how to shoot, pose, light, and edit fabulous images. $34.95 list, 8½x11, 128p, 150 color photos, index, order no. 1828.

OUTDOOR AND LOCATION PORTRAIT PHOTOGRAPHY, 2nd Ed.

Jeff Smith

Learn to work with natural light, select locations, and make clients look their best. Packed with step-by-step discussions and illustrations to help you shoot like a pro! $29.95 list, 8½x11, 128p, 80 color photos, index, order no. 1632.

PROFESSIONAL SECRETS FOR PHOTOGRAPHING CHILDREN

2nd Ed.

Douglas Allen Box

Covers every aspect of photographing children, from preparing them for the shoot, to selecting the right clothes to capture a child's personality, and shooting storybook themes. $29.95 list, 8½x11, 128p, 80 color photos, index, order no. 1635.

STUDIO PORTRAIT PHOTOGRAPHY OF CHILDREN AND BABIES, 2nd Ed.

Marilyn Sholin

Work with the youngest portrait clients to create cherished images. Includes techniques for working with kids at every developmental stage, from infant to preschooler. $29.95 list, 8½x11, 128p, 90 color photos, order no. 1657.

PHOTOGRAPHING CHILDREN IN BLACK & WHITE

Helen T. Boursier

Learn the techniques professionals use to capture classic portraits of children (of all ages) in black & white. Discover posing, shooting, lighting, and marketing techniques for black & white portraiture in the studio or on location. $29.95 list, 8½x11, 128p, 100 b&w photos, order no. 1676.

POSING AND LIGHTING TECHNIQUES FOR STUDIO PHOTOGRAPHERS

J. J. Allen

Master the skills you need to create beautiful lighting for portraits. Posing techniques for flattering, classic images help turn every portrait into a work of art. $29.95 list, 8½x11, 120p, 125 color photos, order no. 1697.

CORRECTIVE LIGHTING, POSING & RETOUCHING FOR

DIGITAL PORTRAIT PHOTOGRAPHERS, 2nd Ed.

Jeff Smith

Learn to make every client look his or her best by using lighting and posing to conceal real or imagined flaws—from baldness, to acne, to figure flaws. $34.95 list, 8½x11, 120p, 150 color photos, order no. 1711.

MASTER POSING GUIDE FOR PORTRAIT PHOTOGRAPHERS

J. D. Wacker

Learn the techniques you need to pose single portrait subjects, couples, and groups for studio or location portraits. Includes techniques for photographing weddings, teams, children, special events, and much more. $29.95 list, 8½x11, 128p, 80 photos, order no. 1722.

THE ART OF BRIDAL PORTRAIT PHOTOGRAPHY

Marty Seefer

Learn to give every client your best and create timeless images that are sure to become family heirlooms. Seefer takes readers through every step of the bridal shoot, ensuring flawless results. $29.95 list, 8½x11, 128p, 70 color photos, order no. 1730.

PROFESSIONAL TECHNIQUES FOR

DIGITAL WEDDING PHOTOGRAPHY, 2nd Ed.

Jeff Hawkins and Kathleen Hawkins

From selecting equipment, to marketing, to building a digital workflow, this book teaches how to make digital work for you. $34.95 list, 8½x11, 128p, 85 color images, order no. 1735.

LIGHTING TECHNIQUES FOR

HIGH KEY PORTRAIT PHOTOGRAPHY

Norman Phillips

Learn to meet the challenges of high key portrait photography and produce images your clients will adore. $29.95 list, 8½x11, 128p, 100 color photos, order no. 1736.

PHOTOGRAPHER'S LIGHTING HANDBOOK

Lou Jacobs Jr.

Think you need a room full of expensive lighting equipment to get great shots? With a few simple techniques and basic equipment, you can produce the images you desire. $29.95 list, 8½x11, 128p, 130 color photos, order no. 1737.

PROFESSIONAL DIGITAL PHOTOGRAPHY

Dave Montizambert

From monitor calibration, to color balancing, to creating advanced artistic effects, this book provides those skilled in basic digital imaging with the techniques they need to take their photography to the next level. $29.95 list, 8½x11, 128p, 120 color photos, order no. 1739.

GROUP PORTRAIT PHOTOGRAPHY HANDBOOK, 2nd Ed.

Bill Hurter

Featuring over 100 images by top photographers, this book offers practical techniques for composing, lighting, and posing group portraits—whether in the studio or on location. $34.95 list, 8½x11, 128p, 120 color photos, order no. 1740.

LIGHTING AND EXPOSURE TECHNIQUES FOR

OUTDOOR AND LOCATION PORTRAIT PHOTOGRAPHY

J. J. Allen

Meet the challenges of changing light and complex settings with techniques that help you achieve great images every time. $34.95 list, 8½x11, 128p, 150 color photos, order no. 1741.

THE ART AND BUSINESS OF

HIGH SCHOOL SENIOR PORTRAIT PHOTOGRAPHY

Ellie Vayo

Learn the techniques that have made Ellie Vayo's studio one of the most profitable senior portrait businesses in the U.S. $29.95 list, 8½x11, 128p, 100 color photos, order no. 1743.

SUCCESS IN PORTRAIT PHOTOGRAPHY

Jeff Smith

Many photographers realize too late that camera skills alone do not ensure success. This book will teach photographers how to run savvy marketing campaigns, attract clients, and provide top-notch customer service. $29.95 list, 8½x11, 128p, 100 color photos, order no. 1748.

PHOTOGRAPHING CHILDREN WITH SPECIAL NEEDS

Karen Dórame

This book explains the symptoms of spina bifida, autism, cerebral palsy, and more, teaching photographers how to safely and effectively work with clients to capture the unique personalities of these children. $29.95 list, 8½x11, 128p, 100 color photos, order no. 1749.

PROFESSIONAL DIGITAL PORTRAIT PHOTOGRAPHY

Jeff Smith

Because the learning curve is so steep, making the transition to digital can be frustrating. Author Jeff Smith shows readers how to shoot, edit, and retouch their images—while avoiding common pitfalls. $29.95 list, 8½x11, 128p, 100 color photos, order no. 1750.

PROFESSIONAL STRATEGIES AND TECHNIQUES FOR DIGITAL PHOTOGRAPHERS

Bob Coates

Learn how professionals—from portrait artists to commercial specialists—enhance their images with digital techniques. $29.95 list, 8½x11, 128p, 130 color photos, index, order no. 1772.

WEDDING PHOTOGRAPHY WITH ADOBE® PHOTOSHOP®

Rick Ferro and Deborah Lynn Ferro

Get the skills you need to make your images look their best, add artistic effects, and boost your wedding photography sales with savvy marketing ideas. $29.95 list, 8½x11, 128p, 100 color images, index, order no. 1753.

LIGHTING TECHNIQUES FOR
LOW KEY PORTRAIT PHOTOGRAPHY

Norman Phillips

Learn to create the dark tones and dramatic lighting that typify this classic portrait style. $29.95 list, 8½x11, 128p, 100 color photos, index, order no. 1773.

THE ART AND TECHNIQUES OF
BUSINESS PORTRAIT PHOTOGRAPHY

Andre Amyot

Learn the business and creative skills photographers need to compete successfully in this challenging field. $29.95 list, 8½x11, 128p, 100 color photos, index, order no. 1762.

THE DIGITAL DARKROOM GUIDE WITH ADOBE® PHOTOSHOP®

Maurice Hamilton

Bring the skills and control of the photographic darkroom to your desktop with this complete manual. $29.95 list, 8½x11, 128p, 140 color images, index, order no. 1775.

THE BEST OF TEEN AND SENIOR PORTRAIT PHOTOGRAPHY

Bill Hurter

Learn how top professionals create stunning images that capture the personality of their teen and senior subjects. $34.95 list, 8½x11, 128p, 150 color photos, index, order no. 1766.

FANTASY PORTRAIT PHOTOGRAPHY

Kimarie Richardson

Learn how to create stunning portraits with fantasy themes—from fairies and angels, to 1940s glamour shots. Includes portrait ideas for infants through adults. $29.95 list, 8½x11, 128p, 60 color photos index, order no. 1777.

THE PORTRAIT BOOK

A GUIDE FOR PHOTOGRAPHERS

Steven H. Begleiter

A comprehensive textbook for those getting started in professional portrait photography. Covers every aspect from designing an image to executing the shoot. $29.95 list, 8½x11, 128p, 130 color images, index, order no. 1767.

PORTRAIT PHOTOGRAPHY

THE ART OF SEEING LIGHT

Don Blair with Peter Skinner

Learn to harness the best light both in studio and on location, and get the secrets behind the magical portraiture captured by this legendary photographer. $29.95 list, 8½x11, 128p, 100 color photos, index, order no. 1783.

DIGITAL PHOTOGRAPHY FOR CHILDREN'S AND FAMILY PORTRAITURE

Kathleen Hawkins

Discover how digital photography can boost your sales, enhance your creativity, and improve your studio's workflow. $29.95 list, 8½x11, 128p, 130 color images, index, order no. 1770.

PLUG-INS FOR ADOBE® PHOTOSHOP®

A GUIDE FOR PHOTOGRAPHERS

Jack and Sue Drafahl

Supercharge your creativity and mastery over your photography with Photoshop and the tools outlined in this book. $29.95 list, 8½x11, 128p, 175 color photos, index, order no. 1781.

BEGINNER'S GUIDE TO PHOTOGRAPHIC LIGHTING

Don Marr

Create high-impact photographs of any subject with Marr's simple techniques. From edgy and dynamic to subdued and natural, this book will show you how to get the myriad effects you're after. $29.95 list, 8½x11, 128p, 150 color photos, index, order no. 1785.

POSING FOR PORTRAIT PHOTOGRAPHY

A HEAD-TO-TOE GUIDE

Jeff Smith

Author Jeff Smith teaches surefire techniques for fine-tuning every aspect of the pose for the most flattering results. $29.95 list, 8½x11, 128p, 150 color photos, index, order no. 1786.

CLASSIC PORTRAIT PHOTOGRAPHY

William S. McIntosh

Learn how to create portraits that truly stand the test of time. Master photographer Bill McIntosh discusses some of his best images, giving you an inside look at his timeless style. $29.95 list, 8½x11, 128p, 100 color photos, index, order no. 1784.

DIGITAL PHOTOGRAPHY BOOT CAMP

Kevin Kubota

Kevin Kubota's popular workshop is now a book! A down-and-dirty, step-by-step course in building a professional photography workflow and creating digital images that sell! $34.95 list, 8½x11, 128p, 250 color images, index, order no. 1809.

BEGINNER'S GUIDE TO ADOBE® PHOTOSHOP®, 3rd Ed.

Michelle Perkins

Enhance your photos, create original artwork, or add unique effects to any image. Topics are presented in short, easy-to-digest sections that will boost confidence and ensure outstanding images. $34.95 list, 8½x11, 128p, 80 color images, 120 screen shots, order no. 1823.

PROFESSIONAL PORTRAIT LIGHTING

TECHNIQUES AND IMAGES FROM MASTER PHOTOGRAPHERS

Michelle Perkins

Get a behind-the-scenes look at the lighting techniques employed by the world's top portrait photographers. $34.95 list, 8½x11, 128p, 200 color photos, index, order no. 2000.

MASTER POSING GUIDE

FOR CHILDREN'S PORTRAIT PHOTOGRAPHY

Norman Phillips

Create perfect portraits of infants, tots, kids, and teens. Includes techniques for standing, sitting, and floor poses for boys and girls, individuals, and groups. $34.95 list, 8½x11, 128p, 305 color images, order no. 1826.

MASTER GUIDE

FOR PROFESSIONAL PHOTOGRAPHERS

Patrick Rice

Turn your hobby into a thriving profession. This book covers equipment essentials, capture strategies, lighting, posing, digital effects, and more, providing a solid footing for a successful career. $34.95 list, 8½x11, 128p, 200 color images, order no. 1830.

DIGITAL CAPTURE AND WORKFLOW

FOR PROFESSIONAL PHOTOGRAPHERS

Tom Lee

Cut your image-processing time by fine-tuning your workflow. Includes tips for working with Photoshop and Adobe Bridge, plus framing, matting, and more. $34.95 list, 8½x11, 128p, 150 color images, index, order no. 1835.